DIGITAL PHOTOGRAPHY

NICK VANDOME

In easy steps is an imprint of Computer Step Southfield Road . Southam Warwickshire CV47 0FB . United Kingdom www.ineasysteps.com

Fourth edition

Copyright © 2002-2004 by Computer Step. All rights reserved. No part of this book may be reproduced or transmitted in any form or by any means, electronic or mechanical, including photocopying, recording, or by any information storage or retrieval system, without prior written permission from the publisher.

Notice of Liability

Every effort has been made to ensure that this book contains accurate and current information. However, Computer Step and the author shall not be liable for any loss or damage suffered by readers as a result of any information contained herein.

Trademarks

All trademarks are acknowledged as belonging to their respective companies.

Printed and bound in the United Kingdom

Contents

The filmle	ess camera	7
	Defining digital photography The first digital steps On the down side Using images on the Web Desktop publishing (DTP) Online sharing Understanding pixels Resolution Viewing and printing images Image compression Colors in digital images Color depth	8 10 12 13 15 16 17 18 20 22 23 24
Equipping	g yourself	25
2	Looking at digital cameras Researching the options Considering computers Choosing a printer Removable memory options Assessing transfer devices Image editing software Storage devices Accessories	26 28 30 33 34 35 36 39
Buying a	digital camera	43
3	Price and range The functions of a digital camera The workings of a digital camera Resolution Memory LCD panel Lenses Flash	44 46 48 50 51 52 54 55

	Batteries Additional features Camera software Other ways to obtain digital images Digital camera checklist	56 57 58 60 62
Captu	ring digital images	63
4	Through the viewfinder Focusing Exposure Using light Depth of field Landscapes and landmarks Buildings People Children Business applications Composition matters	64 65 66 67 70 72 74 75 77 79 80
Using '	Windows XP	83
5	Downloading images Adding digital devices Viewing images Editing and printing	84 88 91 97
Using	Mac OS X	101
6	Downloading images Obtaining iPhoto Using iPhoto Importing with iPhoto Organizing with iPhoto Editing with iPhoto Services with iPhoto	102 103 104 105 106 109

Im	age editing software	111
	Entry-level programs	112
	Professional programs	4
	Opening images	116
	Viewing images	118
	File formats	120
	Saving files	123
	Touch-up techniques	124
	Special effects	125
	Types of projects	126
Ed	liting digital images	127
	The editing process	128
3	Before you start	129
K	Basic color adjustment	130
	Improving brightness	131
	Contrast and saturation	132
	Correcting the balance	133
	Adjusting colors with Levels	134
	Selecting an area	135
	Cropping an image	137
	Reducing red-eye	138
	Sharpening	139
	Blurring and softening	140
	Feathering	141
	Cloning	142
	Recognizing jaggies and noise	144
Fu	rther editing options	145
	Using layers	146
	Creating collages	148
7	Panoramas	150
	Adding text	152
	Adding colors	153
	Special projects	154
	Effects and distortion	156
	Repairing old photographs	158
	Wallpaper	160

Obtaining prints		161	
IC	The printing process Printer resolution Printer settings Printing speed Inkjet printers Other types of printers Selecting paper Ink issues In-store prints Printing checklist	62 63 64 165 166 167 168 170 171 172	
Or	nline images	173	
	Online sharing Online printing Images on the Web Optimizing images Web authoring options Emailing images	174 178 181 182 183 185	
Inc	lex	187	

The filmless camera

This chapter introduces the basics of digital photography and shows the uses to which it can be put. Web publishing, desktop publishing (DTP) and home use are discussed and there is a general introduction to the format and creation of digital images.

Covers

Defining digital photography 8
The first digital steps 10
On the down side 12
Using images on the Web 13
Desktop publishing (DTP) 15
Online sharing 16
Understanding pixels 17
Resolution 18
Viewing and printing images 20
Image compression 22
Colors in digital images 23
Color depth 24

Chapter One

Defining digital photography

Digital photography is a marriage between photographic techniques and

computer technology. If you are interested in both then you will take to it like a duck to water. If your main interest is in one or other of the processes then you will have some enjoyable discoveries as you experience the other side of the equation.

After a relatively slow start in the consumer market, digital photography is now beginning

to get a firm foothold in the mass-market category. Computer and software manufacturers are working hard to ensure that it is as easy as possible for users to get, capture and use digital images.

With recent advances in electronic and computing technology it seems like all of the familiar gadgets around us are being converted into digital versions: televisions, telephones, radios, camcorders and, of course, cameras. The main reasons for this are quality and speed of delivery of information.

Photography has been a willing participant in the digital revolution and it is now becoming strongly established in both the commercial and consumer markets. At first sight, though, digital photography can appear confusing to the uninitiated: in addition to cameras there are computers, image editing software, printers, scanners and a host of other add-ons and peripherals. But the good news is that once some of the technical jargon has been stripped away digital photography is relatively straightforward: you take a picture in the traditional way but with a digital camera; you transfer the image onto a computer; you improve, enhance and edit the image; the final version is then printed, used on a Web page, or displayed on a monitor.

The starting point of any digital photography career is the camera. More and more of these are now appearing in both photographic and computer retail outlets and the choice and quality are increasing continually. Some digital cameras look almost identical to their film counterparts, so there is no need to readjust your perceptions on this front.

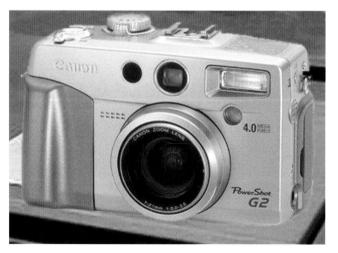

A lot of digital cameras have a familiar look and feel

Using digital photography

There are a variety of ways of capturing digital images and using them but the basic process with a camera is:

In addition to capturing digital images with a camera, they can also be obtained

with a scanner, a Photo CD, a video grabber or from the Internet.

Digital images can also be viewed on a television or used in a multimedia

presentation via a projector.

Some color inkjet printers can print images directly from a digital camera or

a memory card, without the need to first download them onto a combuter.

Begin the digital process by capturing an image with a digital camera

computer

next scheduled ones are:

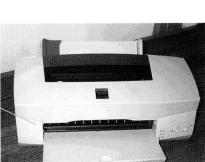

Edit images on a

details about my writing training exploits — I write IT books covering subjects includi

Use images online

The first digital steps

The image sensors in the majority of digital cameras currently available are

called Charge Coupled Devices (CCD). Another type, known as CMOS, is less widely used but gaining in popularity.

An image sensor is a complex biece of equipment that is powered by some

extremely fancy technology. The sensors currently available are equivalent to an ISO film rating of 50-1600 in some models. The average is closer to 100-200.

As far as capturing an image is concerned, digital photography differs very little from film photography. In both cases an image is seen through a viewing device and then light from the displayed image is recorded within the camera. It is in differing methods of recording the amount of light that the first big difference between film and digital photography lies. In the former, the light creates an image on photographic film. This is then developed into a photograph using a combination of chemicals. Digital photography is a lot less messy: the light that comes through the lens is recorded on a tiny computer chip (known as an image sensor). These contain hundreds of thousands or millions of devices called photosites, each of which stores electronic data about the amount of light that falls on it. Once the image has been captured by the image sensor this data is then sent to an Analog to Digital Converter (ADC) which converts the image information into a format that can be interpreted by a computer.

Once the photograph is taken, all similarity between traditional and digital photography ceases. A film image can be developed into a hard copy and that's pretty much it really. A digital image on the other hand can be transferred into a computer and, with the right software, numerous improvements can be made. Colors can be increased or decreased, unwanted objects can be removed (including spots, wrinkles and the dreaded red-eye), new items can be inserted and special effects can be applied.

Effects such as this are available in most image editing programs

Memory cards can be in a variety of formats. The type used will depend on the

type of camera and each camera usually only uses one type of card.

The next generation of image sensors are known as Foveon X3. These

capture a much greater range of color information than CCD or CMOS sensors and they are the first full color image sensors. At present they are only present in top end cameras, but it is only a matter of time before they are more widely available.

For more information, look at the Foveon website at: www.foveon.com

The advantages of digital photography over its traditional counterpart are numerous and appealing:

No more films to buy or process. A digital camera stores image on a reusable disc, or memory card, some of which can hold over 1000 images before they are full:

Memory cards are the digital answer to traditional film. They can hold a large amount of data and once you have downloaded your images you can wipe them clean and start all over again

- You only keep the images that you want. You can delete unwanted images immediately after you have taken them or wait until you have a chance to review all of the pictures you have taken in that session
- Image editing software allows you to become a picture editor and a graphic artist
- Indexing programs, or operating systems such as Windows XP or Mac OS X, allow you to catalog your images on your computer — no more boxes of pictures lying around the house
- Greater versatility in what you can do with digital images. They can be stored electronically, printed, sent around the world via email or viewed in your living room through a slide show on your television
- It is a new and rapidly advancing medium that has enormous potential for development

On the down side

However, as with every type of emerging technology, there are some drawbacks to the digital photography revolution:

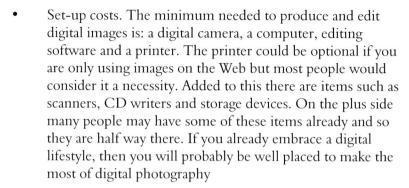

Printing costs. Photograph-quality paper and ink are not cheap and on top of this is the wear and tear on your printer. Some of this is offset by the fact that you will only want to print your best images and you can discard any images that are not up to scratch. Initially, it may seem that digital photography will drastically reduce your photographic processing bill, but this is not always the case. However, you will make some savings if you are using your images online

Emerging technology. Digital photography is taking an increasingly firm hold in the consumer market and the development of the technology is moving very quickly. So what is cutting-edge today may seem obsolete in a year. However, if you keep waiting for the technology to advance and the prices to drop you never feel the time is right. Take the plunge now and be prepared to upgrade as time goes by. If you do, don't go back and look at the price of your equipment in six months

Digital photography is not a cheap hobby.

Do not be put off by the purists of the photography world who reject

digital photography as a gimmick that will not last. These are the same type of people who claimed that the Internet would not catch on.

Using images on the Web

Web publishing One of the main uses of digital photography is for inserting images

Digital images are ideal for emailing to friends, family and colleagues

over the Web. Simply create your email, then attach the image (the Attach function is usually denoted by a paperclip icon or something similar) and send. It's as easy as that.

On a corporate website — pictures to illustrate the site or

resolution and still maintain good quality and reasonable file size.

into Web pages. This is because they can be captured at a low

the CEO's happy, smiling face

On an internal intranet site several companies now have employee photographs next to

their names on an internal telephone directory so that everyone knows what their colleagues look like

For use on a personal website — this could be used to illustrate your hobbies, promote your latest home-made gadget or show pictures of your friends and family to the cyber world:

Web users can change the settings on their browsers so that they do not show

images. This saves the user time but it means that your images may not be seen.

Personal Web pages are a great way to keep in touch with family and friends and also publish information about yourself and your hobbies and interests

Web publishing rules

When you are publishing images on a website a few common rules apply:

- Don't overdo it. Just because you have the capability to scatter dozens of images on a single page, it does not mean you have to use it. More images mean a longer downloading time for the page and this can cause considerable frustration to the user. "Less is more" is a good maxim to follow
- If you have to have a lot of images on one page then create them as thumbnails. These are reduced-size images that can be enlarged by clicking on them:

When you put images on the Web it is possible for anyone to download them

and use them as they please. It is very hard to keep track of images once they appear on the Web. So if you have a valuable image that you do not want to be copied, then do not put it on the Web.

Thumbnails

- Provide a textual alternative for users who do not, or choose not to, have access to images on their browser
- Don't use images just for the sake of it. Each image should carry a powerful and pertinent message
- Don't use any images that could cause offence or distress. This is equally important whether you are creating a business website, an intranet site or a personal one. If in doubt, choose another image
- Never put misleading words or phrases about your images in the meta tag (the bit that is used for indexing by search engines) of your website. This will only annoy, frustrate or disappoint people and they may never visit your site again

Desktop publishing (DTP)

What was once thought of as an area only for professional designers is now open to anyone with a computer and a DTP package such as Adobe InDesign, Adobe PageMaker, QuarkXPress or Microsoft Publisher. These programs enable the users to create professional and high-quality items such as newsletters, magazines, brochures, reports and promotional material. Digital images can easily be incorporated into these publications and the software offers numerous options for both the layout and printing of these images.

When you are using digital images in DTP documents it is important that you know the type of printer the output device is going to be. If you are printing in-house then this should be easy to find out, but if you are dealing with a commercial printer you should do the following:

- Create a spec. sheet of exactly what you want in terms of color, paper and photographic reproduction
- Visit the printer and discuss your requirements
- Liaise with the printer at every step of the process to make sure that it is all going well

These points are particularly important when you are using images that you want to be produced at the highest quality.

Having a DTP document produced on a color photocopier is an effective and

economical alternative to having it printed by a commercial printer. In addition, the quality of some color photocopiers on the market today is excellent.

Digital images can be incorporated very successfully into documents such as newsletters. However, for the best results it is necessary to know how they are going to be printed and involve yourself in the process from start to finish

Online sharing

Digital photography is an excellent medium for beoble with young children.

Online sharing services are an ideal way to then allow people to see them. One of the advantages of this is that you can control exactly who has access to view the images.

Sharing on the Web

The explosion of interest in digital photography has spawned a number of related services and one of these is online companies that allow people to share their digital images over the Web. Rather than having the users set up their own websites to which they publish their images, online sharing involves creating closed communities within the website of the company which is hosting the sharing service. Users are allocated a certain amount of space and they can then upload their images onto their own individual area. This remains private, unless the user wants to invite other people to view their images. This then creates an online community. Most sites allow users to create several communities, so it is possible to have different ones for different groups of friends or family. These services are free (registration is required though) and it is becoming increasingly popular for people to share their images over the Web.

Some companies that offer online digital image sharing include:

- Club Photo at: www.clubphoto.com
- Fotango at: www.fotango.com
- Snap Fish at: www.snapfish.com
- Dot Photo at: www.dotphoto.com

Companies that offer online image sharing usually also have a facility for

ordering prints from digital images. These can also be produced on a variety of gifts such as mugs or T-shirts.

For more information about online sharing and brinting services, see

Chapter Eleven.

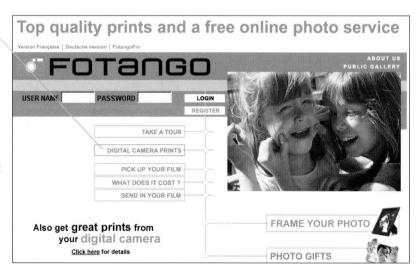

Understanding pixels

Images created with bixels are known as bitmap images. This is because each

pixel (bit) is mapped to a grid which is then used to determine its position within the image. Another type of image is a vector graphic which is created from mathematical formulae. Photographic images are almost always bitmaps.

Using image editing software it is possible to enlarge an image and then change

the color attributes of individual bixels, if you so desire.

Each pixel represents a single color, so for subtle color changes it is best

to have as many pixels as possible. This creates the most accurate color representation.

The technology behind digital photography is undoubtedly complex. Although there is no need to fully understand the inner workings of a digital camera, it is important to know a bit about the overall process of creating a digital image.

Pixels: the digital building blocks

If you are involved with any form of digital imaging it will not be long before you encounter the word pixel. This stands for picture element and it is the foundation upon which every digital image is built. A pixel is a tiny square of color and a digital image is made up of hundreds of thousands, or even millions, of these squares. Each pixel contains photosites, which are used to capture color information about images. If you enlarge a digital image enough it will become pixelated, which means you see each individual pixel rather than the overall image. Since pixels are so small though, once you view the image from a reasonable distance, all of the pixels merge to form (ideally) a sharp and clear image.

When an image is viewed 1:1 it should appear sharp

When a digital photograph is taken, the light captured by the image sensor is converted into pixels, with each pixel representing a certain color. In general, the more pixels that you have in an image then the sharper it will appear. It is easier to get rid of extra pixels than to add new ones.

Resolution

Some digital cameras give resolutions in interpolated values. This is a

process whereby the camera adds pixels to the image. This increases the resolution (i.e. there are more pixels in the image) but it does not necessarily increase the quality accordingly.

Look for cameras that offer optical resolution figures i.e. the actual physical number of pixels that they are capable of capturing.

Types of resolution

The first thing on a specification list for a digital camera is usually the resolution. This records the number of pixels in an image and can be specified in three ways: by its dimensions in pixels, i.e. 640 x 480; the total number of pixels in an image, i.e. 307,200 pixels; or pixels per inch (ppi). In general, the greater the number of pixels in an image then the better the quality. However, more pixels mean larger file sizes. The stated resolution of a digital image is not the physical size of it — this is determined by altering the image resolution in the image editing software. So an image with a resolution of 640 x 480 pixels could be displayed or printed with different dimensions, but the bigger the physical size then the poorer the quality of the image. This is because each pixel would have to be stretched to cover the greater area.

640

480

An image with a resolution of 640×480 pixels (not the physical dimensions)

When looking at the overall bixel count of a digital camera, ask about the effective pixel

count, rather than just the headline figure. The effective count is the amount of pixels that are used to make up the actual image. This is usually less than the headline figure since some of the pixels are required by the camera for calibration and image processing function.

Most entry level digital cameras have a minimum resolution of 640 x 480 pixels. The next step up is cameras that offer a resolution in the region of 1200 x 800 pixels (or 1 million in total) and these are known as megapixel cameras. Megapixel cameras with an overall pixel count of 1 million pixels were once considered state of the art, but now they are very much entry level models. The top of the range cameras are currently capable of capturing up to 6 million pixels in a single image. Understandably, the price of the camera increases with the number of pixels that it can capture but it is worth going for the best one you can afford. One consideration in relation to this is how you are going to use your images: images on the Web can be a lot smaller than those being used for printing.

In most editing packages, when you change the resolution of an image this does

not affect the on-screen view. If you want to change this you can do so by changing the magnification or, in some programs, the canvas size.

Also, changing the image resolution does not change the size of the file, it just means that the bixels will be closer together or further apart when printed.

Image resolution can also be thought of as the outbut image resolution,

because if this figure is changed, this affects the size at which the image is viewed on a monitor or printed.

Image resolution

When it comes to outputting an image, the resolution in terms of pixels per inch is the important consideration. A lot of digital cameras automatically save images at 72–96 ppi. This means that if the image was viewed on a monitor or printed on paper there would be 72 or 96 pixels in each linear inch. So if the number of pixels in the image was 1200 wide and 900 high (the resolution of a mid-range digital camera) then this image could be produced at a size of 12.5 inches by 9.4 inches (1200 divided by 96 and 900 divided by 96). The final quality of the image will depend on the type of output device that is being used.

Resizing an image

The resolution of an image can be set from within the image editing software. Once this has been done the resolution remains the same, regardless of the type of output device being used.

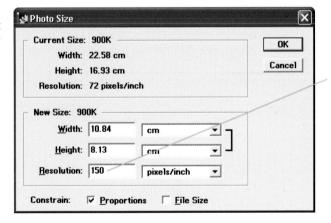

Changing an image's resolution in an editing program alters the output size

Changing the resolution of an image changes the size at which it will appear once it is printed or viewed on screen. If, in the example in the first paragraph, the image resolution was 300 ppi then the image would be output at a size of 4 inches by 3 inches (1200 divided by 300 and 900 divided by 300).

The size of images can also be changed by using a process called resampling. This involves the software adding more pixels to the image using a method of electronic guess work. This creates a bigger image but with lower quality.

Viewing and printing images

It is possible to get very good print quality with a print resolution of 150 ppi, and

even 72 ppi can be acceptable. However, for the very best quality, aim for 300 ppi, if the overall size of the image allows for this. If the image is too small for the required output size at the selected print resolution, then a lower resolution will be required.

Always aim to work with up to 300 ppi as the optimum print resolution. The

printer resolution is the number of colored dots that the printer can but on an inch of baber. print resolution determines how many pixels are placed within each inch.

So if the print resolution is 300 pbi and the printer resolution is 2880 DPI, each pixel will be printed by 9.6 dots of color (2880 divided by 300).

The issue of resolution becomes important when you want to display your images because it affects the size at which they can be viewed satisfactorily. The two main areas are displaying online and printing hard copy.

Of the two, using images on the Web is the more straightforward. Most computer monitors display images at 72 or 96 ppi so an image that has a resolution of 640 x 480 pixels can be viewed at a size of approximately 9 inches by 6.5 inches. (This is calculated by dividing 640 and 480 by 72.) If you want a larger image then the quality will decrease slightly because each pixel will have to increase in size to cover the extra area.

When digital images are printed as hard copy the same calculation can be applied — the dimensions of the image (in pixels) divided by the resolution set in the image editing software (this is sometimes known as print resolution and can also be thought of as the output resolution). The best output image resolution setting for color inkjet printers is 300 ppi as this gives the best output quality. So to print an image with the dimensions of 640 x 480 at a resolution of 300 ppi the resulting size would be:

640/300 = 2.13 inches

by

480/300 = 1.6 inches

By anyone's standards this is small for a printed photograph. You can increase the size by setting your output image resolution to 72, but this would result in a lower quality of picture because 72 colored dots in an inch are a lot less tightly packed than 300. So if you want to take digital images for printing hard copy then go for a camera with as high a resolution as your budget can stretch to.

The best way to see how printers handle digital images is to get a demonstration from a retailer. If possible take one of your own images for them to use rather than the pre-installed ones in the shop. This way you will see a truer result for your own needs rather than relying on an image that is designed to show the printer in its best light.

"Resolution" is a popular term in the imaging world and is also used in relation to

monitors and printers. Make sure you know what is being referred to when you hear the word "resolution".

A printed image will always look better on high quality photographic

paper than standard multicopy paper.

Try not to get pixels per inch (bbi) confused with dots per inch (dpi). Think of ppi

in relation to images on a computer monitor and dbi in relation to images when they are printed out in hard copy.

A whole book could be written on the topic of pixels and resolution, and they have been, but the main points to remember are:

- The more pixels in an image then the better the quality will be from the output device
- When calculating the physical output size of your image, divide the number of pixels across (or down) by the output image resolution (also known as print resolution) set within the image editing program
- For images that are going to be displayed on the Web, set the output resolution to 72 or 96 (ppi)
- For images that are going to be printed, set the output resolution to 300 (ppi)
- Image resolution can be altered in the editing software
- The higher the image resolution then the larger the file

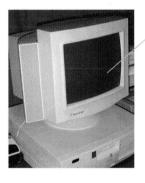

If an image is being viewed on a monitor then the size it can best be displayed at can be calculated by setting the output resolution to 72 or 96 (the resolution of the monitor)

If an image is being printed then the output size can be calculated by setting the output resolution to 300 (the ideal resolution for the printer)

Image compression

One of the most popular photographic file formats, IPEG (loint

Photographic Expert Group) has been designed so that it handles compression well. This means that it produces good quality images while maintaining small file sizes.

Each time a IPEG image is opened and then saved it is compressed. This

means that if a lot of editing is done to a IPEG image, the overall quality can deteriorate. If this is the case, perform the editing in an image format that does not use compression (such as TIFF) and then save the final version as a IPEG.

A newer file format, PNG (Portable Network Graphics), is similar to IPEGs

but is not as widely used.

Most digital cameras offer a variety of compression settings when an image is being captured. This involves creating a smaller sized image file by discarding some of the pixels that the camera decides are superfluous. This inevitably leads to some loss of image quality but it does mean that more images can be stored when you are taking pictures. Typically, digital cameras have compression settings along the lines of Good, Better, Best. These refer to the final quality of the image – Good is the most compression, Best the least.

The amount of compression used will depend on what the image is going to be used for:

- An image for a website does not have to be of a high resolution so this can be taken on maximum compression
- A image that is going to be printed as a hard copy will be required to be of the best resolution available and so minimal or no compression should be used

Although the idea of compression sounds like a drawback as far as the quality of printed images is concerned this is not necessarily the case. With the naked eye the quality of a moderately compressed image is little different to that of one with no compression. In addition, compressing images can be useful if you are taking some preliminary shots to gain the best angle or view of a subject.

The amount of compression affects the overall size of an image and this in turn determines the amount of images that can be stored on a camera's memory card. So if an image has no compression, it will be larger in file size than one that has the maximum amount of compression applied to it. This can be a factor if you do not have ready access to a computer to download your images once they have been captured (for instance, if you are on holiday). In cases like this it may be necessary to increase the amount of compression in order to store more images on your memory card.

When determining the size of images being captured by a digital camera the level of compression and the resolution are the two major factors. Both of these can be altered to change the overall quality and size of individual images.

Colors in digital images

The color in a digital image is based on the RGB (Red, Green, Blue) color model. This is the method of creating colors that is used by both digital cameras and computer monitors (and also devices such as televisions). To achieve the color that the human eye sees, a RGB device mixes red, green and blue to produce the final multi-colored image. This can produces images with up to 16 million colors in them.

As far as capturing a digital image is concerned, it is enough to know that RGB is the color model that digital cameras use. However, it comes into its own when the image editing software takes over. With these programs you can alter the levels of RGB in an image. This allows for considerable subtlety in the editing process.

In top-of-the-range image editing programs, the RGB model is broken ub into

the individual colors, also known as color channels. Each channel can then be edited independently of each other.

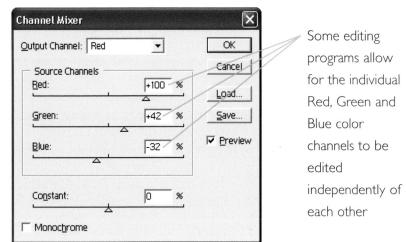

Although digital cameras and computer monitors use the RGB color model, printers (unfortunately from a simplicity point-ofview) use the CMYK (Cyan, Magenta, Yellow, Black) color model. This is because most color printers are not able to reproduce all of the colors that the RGB model can since ink is not as pure as natural light. Therefore black (the K in the CMYK color model not B in case people confuse this for blue) is used to create pure black and also correct any color variations. As far as converting a RGB image into a CMYK hard copy is concerned, this is usually taken care of by the printer software.

Color depth

The final quality of the color in a digital image depends on the number of bits that are used to make up each pixel. A bit (short for binary digit) is the electronic representation of either 0 or 1, also known as binary code, which is a language universally understood by computers. Each bit in a pixel is used to store important data about the color of that pixel: the more bits, the more information stored and so the final image is of a higher quality.

When calculating file size, it is worth remembering the basics of file measurements:

- 8 bits = 1 byte
- 1,024 bytes = 1 kilobyte (1K)
- 1,024 kilobytes = 1 megabyte (IMb)
- 1,024 megabytes = 1 gigabyte (IGb)

The number of bits used to make up a pixel of color is known as

- means that each pixel is made up of 8 bits. The figure of 256 is arrived at because since each bit can be either 0 or 1 the total number is 2 to the power of 8, which is 256
- 24-bit, which gives a total number of 16.7 million color combinations (2 to the power of 24)

The higher the bit depth of the image then the larger the size of the image file, since each bit takes up room in the file. Therefore file formats that are designed for specific purposes have different bit depths: a GIF file, which is used for Web graphics, is an 8-bit (256) colors) format while a JPEG format (which is also used for Web images, but specifically photographic ones) is a 24-bit (16 million color) format. When you are considering color depth, you will have to decide whether you want the highest color quality possible and a larger file, or a slightly inferior color quality and a smaller file.

The color depth of an image does not affect the number of pixels that are used to make it up: a 24-bit image with 1 million pixels, still has the same number if it is displayed as an 8-bit image. However, the 24-bit version will result in a much larger file.

It is possible to have a higher color depth than 24-bit but this is the level at which most computer software and output devices currently operate most efficiently.

A 256 color image creates a file size of approximately one third less

than a 16 million color one. This varies between different file formats.

Equipping yourself

Knowing what you need to take effective digital photographs can be a daunting prospect at first. This chapter shows you the equipment that you will need and some of the areas to consider when you are buying it.

Covers

Looking at digital cameras 26
Researching the options 28
Considering computers 30
Choosing a printer 33
Removable memory options 34
Assessing transfer devices 35
Image editing software 36
Storage devices 39
Accessories 41

Chapter Two

Looking at digital cameras

At first sight the range of digital cameras is both dazzling and bewildering. Some of them look like conventional compact or SLR cameras, while others resemble something out of a science fiction series. As yet there is no standardized design for digital cameras so the first thing to say is, forget what it looks like, make a close inspection of what it does. If it looks sleek and shiny, but does not do the job you want it to, then move on to another model.

The price range for digital cameras is considerable (probably greater than for traditional film cameras), but there is something that is now affordable for every level of digital photographer; from the casual image taker to the professional snapper. Before taking the plunge it is important to ascertain what it is you are going to be using a digital camera for. Some of the options include:

- Capturing images for display on Web pages
- Online distribution to friends and relatives via online sharing services and email
- Using images for business presentations, with a presentation package such as PowerPoint
- Printing medium-quality snapshots
- Printing high-quality prints
- Creating publication-quality DTP documents

Each of these options will require a different specification from the camera. For Web images, and on-screen presentations, an entry level model would suffice (although you may want a higher specification if you are going to print your business presentation in hard copy) while the higher the print quality you require, then the more advanced the camera will need to be.

It is easy to become dazzled by the sheer volume of gadgetry associated with digital cameras. The devices themselves are beguiling objects and it is possible to let your heart rule your credit card when it comes to buying one. Before you make a choice, take some time to assess your needs in relation to the options on offer.

Digital cameras are brime candidates for retailers who like to bush

extended warranties with their products. If you do want this type of service it is usually cheaper to get it from a specialist insurance company.

Some digital camera makers pride themselves on trying to produce the

smallest digital cameras on the market. While this is a considerable technological achievement, it is not always the best option for the user: small cameras can be harder to use effectively (lenses can be obscured by fingers) and they can be lost more easily.

It's more than just a camera.

When you buy a digital camera you will discover that it consists of a lot more than the camera itself. There will also be:

- Cables to connect it to a computer. These can be used to connect the camera to the computer once the camera software has been installed. This enables the camera and the computer to communicate with each other
- Some form of transfer device to get the images into the computer. In some models this is done by connecting the two devices by cables. However, in more recent models this has been superseded by memory card readers of various descriptions or even infrared transmission
- Software to edit the images and, in some cases, software to create Web pages. The standard of these is usually proportionate to the price of the camera but even the entrylevel models have software that is perfectly adequate for general image editing

If you are using an operating system on your computer such as Windows Me.

Windows XP or Mac OS X. images can be downloaded very efficiently with a USB (Universal Serial Bus) cable connection.

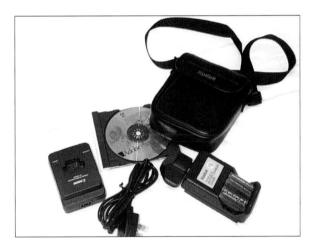

Digital photography uses a variety of accessories, some essential and others only desirable

All of the above are important for the overall imaging process so it is worth examining closely what different models offer. Discuss with your retailer the pros and cons of various models and if they are not prepared to spend time with you then go somewhere else.

Researching the options

One area of research that is often overlooked is asking people who use digital

cameras. If you do this, try and find two or three users so that you can get a good overview.

PC magazines are also a valuable source of information about items such

as printers, scanners, storage devices and software.

Because of the diverse range of digital cameras on offer, and the different uses for them, it is essential to do some research into the subject before venturing off to dispense your hard earned cash. If you walk into a computer or photography shop with little knowledge of the options available then you may come out with a very expensive mistake.

Luckily there is plenty of help at hand when looking into the varied world of digital cameras:

- Camera magazines. Traditional photography magazines are slowly beginning to realize that digital photography is here to stay and more features on this area are starting to appear. In addition, they are also useful for general photography tips which can be applied equally well to digital photography
- Computer magazines. General computer magazines frequently carry articles on digital photography including reviews of new products. It is best to read at least two or three different publications so that you get as balanced a view as possible
- Consumer magazines. Magazines such as Consumer Reports periodically review the latest digital products and it could be worth keeping an eye out for these. They have a website at www.consumerreports.org although there is a subscription fee for some services. Most large libraries carry back copies and also indices of subjects that have been covered

There are numerous online sites offering reviews and views about all aspects

of digital photography.

Another source of information about digital photography is from Newsgroups

on the Internet. These are groups of like-minded individuals who communicate with each other on the Internet. There are thousands of these Newsgroups, covering a multitude of subjects. It is free to join a Newsgroup and you can either see what everyone else has to say or add vour own comments.

Contact your Internet Service Provider for more details.

There are a lot of very useful sites on the Internet that provide reviews

of the latest digital image products, particularly cameras. Some to look at are:

- http://www. dpreview.com
- · http://www. shortcourses.com
- http://www.lone stardigital.com

The Internet. The Web is an ideal source of information on digital imaging. A good way to start is to enter "digital photography" or "digital imaging" into an Internet search engine. There are several online magazines that offer up-todate news and reviews. Some websites to try are www.pcphotomag.com, www.digicamera.com and www.pcmag.com (this is a general PC magazine but it carries a lot of digital imaging features). Also, the websites of companies such as Kodak (www.kodak.com), Olympus (www.olympus.com) and Nikon (www.nikonusa.com) have general digital imaging information

Sites such as www.pcmag.com frequently carry news and reviews about all of the latest digital imaging products

Professional camera/computer stores. The key word here is professional. You should be able to walk into a shop selling digital cameras and get an informed view of the subject without a hard sell sales pitch. In general, smaller specialist shops are more willing to take the time to explain the subject than the larger electronics stores. When you are actually buying a camera, ask to test all of the models in which you are interested

Considering computers

The latest version of the iMac is a thing of considerable beauty and could

turn the head of even the most ardent PC user. It is also very digital-image-friendly.

Digital images can usually be viewed in either PC or Mac format. Most

digital image formats are compatible with both platforms so they can be shared between the two.

See Chapter Six for a more detailed look at Apple's iPhoto digital imaging

software.

PC or Apple Mac?

Thankfully the long-running question of compatibility between PCs and the Apple Mac is one that does not need to overly concern the digital photographer. Digital camera manufacturers are well aware of this potential conflict and most devices are compatible with both types of machine. Most digital cameras on the market today can be connected to a PC or a Mac using USB cables, one of the most widely used and fastest ways of transferring data from an external device onto a computer. If in doubt, ask your retailer.

If you already own a computer then there is no great need to worry about compatibility issues, just double-check when you are buying a camera. The only time when it may be an issue is if you have a very old operating system. If you are buying a new computer then it is a matter of personal choice. Macs have traditionally been the favored platform for designers and graphic artists and they are well equipped to handle complicated image editing, particularly with their stunningly designed new iMac and user-friendly iPhoto software. Alternatively, PCs are used by approximately 90% of computer users and so there is a wider range of software and accessories available. If you want safety in numbers then go for a PC; if you want to assert your individuality then a Mac is perhaps the way to go.

Processor speed

It is a generally accepted fact in the computer world that what is a lightning fast processor today will be a deadly slow one tomorrow. To run most image editing software a minimum of a good quality Pentium chip (or Mac equivalent) is usually required. If possible, go for the fastest processing chip that you can afford. Once you start editing images you will soon realize it can take a reasonably long time for editing changes to be applied to even a moderately small image. The more powerful your computer system, then the more enjoyable the image editing process will be.

However, processor speed is not the only consideration when considering your computer's ability to process and store information. In some cases, a well set up computer with a slower processor can work more efficiently than one with a more powerful processor that has not been as well made.

If you are confident about examining the insides of your computer then it

is reasonably easy to insert extra RAM yourself. However, if you feel unsure then take it to a specialist computer shop. If you do install it yourself it may invalidate your original warranty.

If you develop a liking for digital photography and then want to expand into

digital video you will certainly require as much RAM and hard drive space as possible. Digital video is usually measured in terms of Gibabytes rather than Megabytes as far as file size is concerned.

RAM and hard drives

The two types of computer memory, RAM (Random Access Memory) and the computer's hard drive, are important to the digital editor for different reasons. The amount of RAM affects how quickly the computer will be able to process the image when it is being edited and the hard drive will determine the storage capabilities of the computer, for both the editing software and the completed images.

If you ask anyone who works with computers for the single most valuable upgrade for their system the chances are they will say RAM. It is fair to say that you can never have too much RAM, particularly if you are doing a lot of image editing (256Mb is a good starting point), which can consume large chunks of this valuable commodity. The amount of RAM not only affects the processing speed of your computer, it can also determine whether the machine crashes at regular intervals or not. If a computer is struggling for memory when processing an image it may decide to give up the challenge.

A computer's hard drive is used to store files and also the software that is put on the system. Some modern consumer computers come with enormous quantities of hard drive space - over 120Gb (gigabyte) in some cases. While it is unlikely that you will fill up that much in a short space of time it is nonetheless worthwhile trying to have as much hard drive memory as possible. There are two reasons for this:

- As you do more digital photography it is inevitable that you will want to add more software to your system and image editing software is invariably memory-hungry
- The more you experiment with digital images, the more you will acquire. Imagine if all of the photos lying around the house were to be transferred to your computer. Before long your hard drive will start filling up and there may come a point when you will want to investigate some of the storage devices looked at later in this chapter
- As you do more work with digital images you will come to have higher expectations from your computer

Some image editing software can calibrate your monitor so that the color on

screen is as close to the printed version as possible.

Flat screen monitors are becoming more popular with computer users

and it has been predicted in some quarters that the CRT version of monitors will eventually be surpassed by the flat screen variety.

If you try to edit digital images with a low-spec machine (i.e. 32Mb of RAM

and a 2Gb hard drive), you may find that it is a very slow process and your computer crashes regularly.

Monitor size

When you are doing a lot of image editing work the size and quality of monitor can become an issue. If you are using a 14–16 inch screen, which comes as standard with many computers, you may find that after a period of time you are straining to see your work. Also, if you are working with several different toolbars then these may take up a considerable amount of your editing space. If possible, go for a 17 inch monitor or higher, but the bigger the better as far as digital image editing is concerned. Also, use a glare guard over your monitor to reduce eye strain.

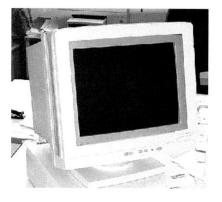

If you are going to be doing a lot of image editing then a large monitor and a glare guard are essential

Check the specification

Before you buy a digital camera, check the specification sheet that comes with it to make sure that your computer's operating system is compatible with the digital camera and also any image editing software that you intend to use.

As a guideline, these could be considered as the minimum specifications required from a computer when dealing with digital images. If possible, aim for the best you can afford:

Pentium III processor (G3 on a Mac), 128Mb RAM, at least 20Gb hard drive

These are not the minimum requirements needed to download and edit digital images and the process can be done with a considerably less powerful machine. However, these can be seen as the minimum requirements to make the process enjoyable and reasonably stress-free.

Choosing a printer

As well as the printers there are also print consumables such as paper

and ink to consider.

There are now several printers on the market that accept both CompactFlash

and SmartMedia memory cards. They are slotted into the printer and the images can then be printed. This is a considerable innovation because it allows for printing images without the need for a computer.

Some printer manufacturers, such as Canon, produce printers that connect

directly to their own digital cameras.

Once the work of capturing, processing and editing a digital image has been completed it is time to look for an output device. If the image is being displayed on the Web then this solves the problem – the image merely has to be inserted into a suitable format and then published on the Web. During the whole operation the image never leaves the safe environment of the computer.

However, if you want to have a printed image of your endeavors, as most people do at some time, then you will need some form of printing device for outputting your image. Although the market for printing digital images is dominated by one type of printer, there are several options from which to choose:

- Inkjet printers. By far the most common type of color printer for digital images. Inkjet printers are relatively cheap, easy to use and, given the right circumstances, can produce excellent near-photographic quality. The technology in this area is improving all the time and the output quality is getting better and better
- Laser printers. Color laser printers produce good results but they are expensive. Business use is the best bet for this type of printer
- Dye-sublimation printers. This type of printer produces a continuous tone image by welding colored dyes onto the paper by a heat process. It is generally accepted that dyesublimation printers produce the closest results to actual photographic quality. However, some of the ones on the consumer market only produce small prints (either passport photo size or 5" x 4" approximately). Their other main drawback is that they can only be used for color printing, so you would need a separate printer for your textual printing needs. It is likely that this type of printer will become more and more popular in the near future
- Micro dry printers. These printers use a similar process to dye-sublimation printers but use an ink-coated ribbon instead of dyes. Can also print text

Removable memory options

If you do not want to cable your camera into the computer to download your

images, removable forms of memory need an adapter or a card reader in order to get the data into the computer. In some cases this is an adapter that can be inserted into your computer's floppy drive and in others it is a separate reader into which the card is inserted.

Check carefully when you are buying a camera to see what type of removable storage it has and how this is downloaded.

Most digital cameras currently use some form of removable memory (also known as flash memory), on which images are stored once they have been captured and processed through the camera. This is now a growth area of digital photography and there are an increasing number of removable memory options:

- CompactFlash. One of the market leaders in the removable memory sector, CompactFlash cards are used by a large number of digital camera manufacturers. They usually come in sizes of 8 Mb to 1 Gb but there are also some cards being developed that have an even greater capacity
- SmartMedia. The other main player as far as removable memory is concerned. SmartMedia cards come in similar sizes to CompactFlash but they are slightly smaller in physical size
- xD Memory Card. This is one of the smallest types of removable memory, but it has a high storage capacity and a fast rate of data transfer
- Memory stick. This is a versatile form of removable memory and it is used in a variety of devices including digital cameras
- SD Card. Another very small and light form of removable storage, the SD Card is gaining in popularity with some digital camera manufacturers
- Multimedia Card. Similar in size to the SD Card, the Multimedia Card is ideal for manufacturers who want to create ever smaller digital cameras

The type of removable memory will depend on the model of camera but CompactFlash and SmartMedia are by far the most common at the present time. These devices are relatively economical since they can be reused numerous times. However, they are very small and delicate so take good care of them. Occasionally, removable memory cards need to be reformatted and this can usually be done within the camera, either through the camera's menus or through the system software that is provided with the camera.

Memory sticks are used mainly in Sony digital cameras. Some Sonv cameras

have also used floppy discs in the past.

Assessing transfer devices

On most new computers the cable connection is through a USB (Universal Serial

Bus) port which speeds up the downloading time considerably. If possible, try to use a computer with a USB connection.

The two main makers of combuter operating systems (Microsoft and

Apple) have designed their latest operating systems (Windows XP and Mac OS X) to make downloading digital images as easy as possible.

Once you have captured your images onto your camera's memory, you will need some method of transferring them onto the computer. There are two main options available: cable transfer and a card reader.

Cable transfer

This method is used most frequently if a camera has some form of on-board memory. However, it can also be used if there is a removable storage device in the camera, such as a disc of some type. To conduct this method of transfer a cable is attached to the camera and a COM port (on a PC) or into the printer or modem port (on a Mac) at the back of the computer. The data is transmitted through the cable into the computer. However, this has two main drawbacks:

- It can be slow if a serial cable connection is used
- It can be irritating to have to fumble around with yet more cables at the back of the computer every time you want to download images

Card readers

Card readers can be connected to computers and then used to download images directly from a camera's memory card. They usually connect by a USB cable and they generate very fast download times. Once they are connected they show up as a separate drive on the computer, like a floppy disc drive. Once the memory card has been inserted, images can be accessed straight from the card. The most popular make of card reader is the SanDisk and more information can be found at their website at www.sandisk.com

In the past, some cameras have used infrared as a method of downloading

images. However, this proved to be slow and erratic and now USB cable transfer and card readers are the standard.

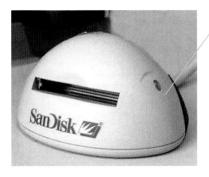

A SanDisk card reader which can be used as a separate drive to download images from a memory card to a computer

Image editing software

Technically, it would be possible to capture digital images and print them out without ever introducing image editing software into the equation. However, you would not be able to amend or manipulate your images, so one of the main assets of digital photography would be lost.

Image editing software allows you to edit the color attributes of an image, add your own text or graphics, apply touch-up techniques and incorporate them into designs such as greeting cards, gift tags or posters.

The bad news about imaging software is that it can be expensive for the most sophisticated programs. But the good news is that there are numerous entry level programs that give an excellent introduction to the subject. Even better, all digital cameras come with some type of imaging software. Some even come with the top-of-the-range packages.

Professional programs

The accepted market-leader for professional image editors is Adobe Photoshop. This does everything you could ever want from an imaging package and more besides. However, for the novice it can be quite daunting to use and is best suited to people who have some prior experience of the digital imaging world. Having said that, there is certainly nothing to touch it as far as versatility, functionality and quality are concerned.

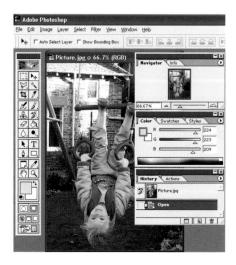

Programs such as Adobe Photoshop are excellent for image editing, but at first sight they can be a confusing collection of menus, toolbars and icons

A try-out version of Photoshop can be downloaded from Adobe's website at

www.adobe.com. It contains most, but not all, of the features of the full program, except you cannot Save or Print any files. A try-out version of Photoshop Elements can also be downloaded.

Entry-level programs offer every assistance during the editing process. Take

some time exploring the Help features and going through the online tutorials.

Some good quality free image editing programs can be downloaded from the Web. One of

the best sites to try is CNET at www.cnet.com

In some entrylevel programs, the editing functions are controlled by

selecting the effect that you want through an icon and then dragging and dropping it into the image to be edited.

Entry-level programs

While entry-level imaging programs do not offer the finesse of their professional cousins, a lot of users will not miss these subtleties. A lot of less expensive programs still offer color controls, special effects and touch up techniques. With very little experience it is possible to create digitally enhanced images that will have people thinking that you have been doing it for years.

The great advantage of these programs is that they are very user friendly and guide the novice user through the whole process of digital imaging with the aid of icons, help assistants, templates and wizards.

Another feature is the uses you can make of your images with these programs. In addition to merely enhancing them you will be able to create cards, posters and invitations incorporating your favorite images and also email them to friends and family via your imageediting program. With some programs you can also create slide shows, print images for T-shirts or design your very own personalized mug. The emphasis with these programs is to make image editing as easy and hassle-free as possible. But most of the programs still manage to pack in an enormous number of functions.

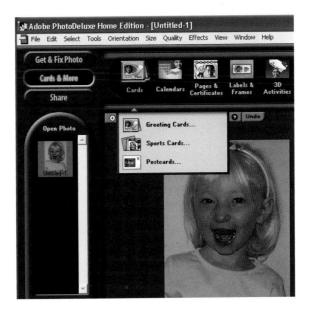

An entry-level editing package can offer a variety of editing options within an easyto-use interface

Fun packages are an excellent way to broduce photographic caricatures.

However, do not overdo the distortion to the point where it becomes over-the-top.

Fun packages

Digital photography is supposed to be fun and some programs take this to extremes by allowing images to have numerous special effects applied to them. This can include distorting images so that they resemble bizarre caricatures or creating patterns by duplicating images, or merging items from different images to create your own e-fit image from parts of your family and friends.

The technical side of these programs involves shifting the pixels in the image around like shifting sand around in a sandpit. The practical side is that it can be a lot of fun for everyone:

> Special effects editing packages can produce amusing, if somewhat unflattering, images

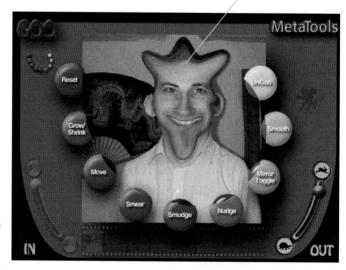

Three funorientated imaging packages include Kai's SuberGoo.

Professor Franklin's Instant Photo Effects and LivePix Deluxe.

Fun packages such as this one are ideal for children for the following reasons:

- They give a good introduction to basic computer techniques
- They are fun and easy to use, while still stimulating creative instincts
- They are ideal for wet holiday days when the kids are getting fed up!

Storage devices

As you collect more and more digital images there will probably come a point when you will want to store them on something other than your computer's hard drive. There are two reasons for this:

- Purely for back-up, in case your hard drive fails
- In order to free up space on your hard drive for your other computing needs

Floppy discs

Most computer users are familiar with floppy discs. They are cheap, straightforward to use and relatively robust. But for digital images they are not ideal. This is because they only hold a maximum of 1.4Mb of data. This is enough to hold a few low resolution, high compression images but for anything much bigger they are too small.

Zip drives

One of the success stories of computer storage in recent years has been the Zip drive. This is similar to a floppy disc drive, except that the discs hold 100Mb of data. This is for the standard model and there are options that offer up to 1Gb of storage. Zip drives can be internal or external. The external version is connected with standard cabling to a parallel port (or, increasingly a USB connection) at the back of the computer. A recent addition to this range is a 250Mb Zip drive. This can also read 100Mb disks, but the 100Mb drive cannot read the 250Mb discs.

If your computer only has one parallel port and your printer is already connected

to it, you can cable the printer through the Zip drive. Detach the printer cable and attach it to the connector at the back of the Zip drive. Then connect the Zip cable to the computer's barallel bort.

To see the full range of Zip drives and discs, have a look at the lomega website at

www.iomega.com

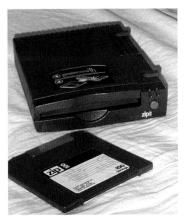

Zip drives can be used in the same way as a floppy drive, with files being copied to it via your hard drive. However, they hold a minimum of 100Mb of data

CD Writers come in both internal and external varieties. The type that you choose

may depend on your ability to fit it internally and the amount of space on your desktop.

CDs that can only be copied onto once (CD-R) are cheaper than the ones that can be

reused numerous times (CD-RW). Both are cheaper if you buy in bulk.

The process of copying a CD is known as "burning". This is done with a CD

Writer and the appropriate software. To try to avoid wasting discs, burn CDs at the lowest speed that your CD Writer will allow (e.g. 1X or 2X). This will give the software more time to transfer the data and there is less chance of a disruption in transmission causing the process to fail.

CD-ROMs

CD-ROMs offer 650Mb of data storage and this option is becoming increasingly popular. Images on CD-ROMs can either be created by a professional bureau or you can create your own using a CD writer. This is a device that transfers images (among other items) from your computer onto a CD-ROM. This is an area that is developing quickly and is becoming more and more popular with users.

Initially it may appear that a CD's 650Mb of storage space is an enormous amount and you will only ever need one CD. But while a CD has approximately 430 times the storage space of a humble floppy disc, you will be amazed at how quickly you fill one up. As your digital photography repertoire expands so will your collection of images. It is a harsh fact of computer storage life that there is no such thing as too much storage capacity.

One important issue with creating your own CDs is format. Some CDs can be copied as read-only (CD-R) which means you cannot erase any data from them and you cannot reuse them once they are full. The other format is rewritable (CD-RW) which means you can delete or copy over items that are already on the disc. This gives you more versatility but there is also the risk that you could record over an image that you wanted to keep. Also, since CD-RWs have come onto the market more recently, some older CD-ROM drives cannot read them.

Archiving images

The best way to archive digital images is on a CD or a DVD. The current archival lifespan for the range of CDs and DVDs on the market is anything from 30 years to 100 years. This is because the coating on the discs can deteriorate over time. However, the data on the discs can always be copied again in a few years time and with the advances in technology it is likely that within a decade there will be a new form of storage for archiving digital data.

CDs are an excellent way to save and keep your images. Don't underestimate the importance of this - in 100 years time your descendants will appreciate the fact that you took the trouble to archive your images.

Accessories

The RadioShack stores offer a wide range of digital photography equipment and

accessories. They also have an online store at

www.radioshack.com

If you are going to be using a tripod a lot it is a good investment to buy a sturdy one. They

can undergo a fair amount of wear and tear during normal photographic duties.

If you are one of those people who believe you will never get caught up in the giddy world of accessories and peripherals, then think again. Digital photography is a magnet for add-ons and extra gadgets and in this respect it could give the computing world a run for its money. Some of the items that you may want to consider to satisfy your craving for more accessories are:

- A camera bag. This could be seen as a necessity rather than an accessory (when you start thinking like this then you know you really are hooked). If you have bought a delicate piece of technology for several hundred pounds then it makes sense to try and keep it as secure as possible. Some models come with their own bags, but if you want something a bit sturdier then try a specialist camera shop
- A tripod. A standard piece of equipment for some photographers, while others do not consider it necessary for their type of photography. As a rule, if you would use one for traditional photography, then do so for the digital variety. With the increase in availability of SLR digital cameras, the need for tripods could be increased

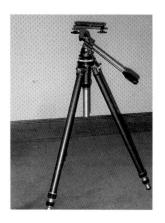

A good quality tripod is a worthwhile investment for a digital photographer. The best way to test them is to press down on the neck of the tripod. If it remains firm and stable then it should be sturdy enough for most uses

Extra memory cards. At least one card is usually supplied with the camera but it is always a good idea to have a spare one. This can come in useful if your working card becomes full or damaged. It can also be very useful if you do not have ready access to a computer

If you invest in a battery charger then you will save a lot of money on new batteries.

However, it still costs money to recharge the batteries and this can take up to eight hours for a standard charger. High-end chargers can do the job in half that time.

- Additional lenses. With some digital cameras it is possible to get lens attachments, such as you would fit on a standard SLR (Single Lens Reflex) camera. These include close up lenses, wide angle lenses and telephoto lenses
- Cleaning equipment. It is good practice to clean your camera and it will certainly not do it any harm. One simple but useful item is a lint-free cloth. This can be used to clean the LCD panel, which has a habit of smearing easily

If you are well and truly bitten by the accessory bug then it will be a costly habit and

one that is hard to break. But at the same time, it will give you a lot of fun.

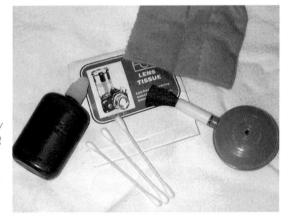

Cleaning equipment can include a lint-free cloth, a lens cleaner, an airbrush, cotton buds and cleaning fluid

Buying accessories

It pays to shop around for all items related to digital photography and this is particularly so with accessories. Due to the nature of the medium these are now appearing in photographic stores, computer stores and also general electrical stores. Look for the best price and also the best service. If you can build up a good relationship with a retailer of digital accessories then this may come in useful in the future.

Buying a digital camera

This chapter sets out some of the things to look for when you are buying a digital camera. It also looks at some of the other items associated with digital cameras.

Covers

Price and range 44
The functions of a digital camera 46
The workings of a digital camera 48
Resolution 50
Memory 51
LCD panel 52
Lenses 54
Flash 55
Batteries 56
Additional features 57
Camera software 58
Other ways to obtain digital images 60
Digital camera checklist 62

Chapter Three

Price and range

At the early stage of their development, the price of digital cameras was a major deterrent to many people buying them. However, this has now changed dramatically, to the point where good quality digital cameras are now affordable for most people. In addition to this, top of the range digital models, such as digital SLR cameras, have fallen even more steeply in price. They are now in the range of thousands of dollars (or pounds), as opposed to tens of thousands as they were a few years ago. This is still too much for the majority of consumers, but it does mean that they have become affordable for professional and serious amateur photographers.

Although digital cameras may not always be displayed in the following categories in retail outlets, the three main general groups of digital cameras are:

- Consumer
- Mid-range
- Professional

Consumer cameras

These are the mostly widely available type of digital camera currently on the market. A lot of them offer excellent quality and they are more than adequate for all but the serious amateur or professional. Some of the general characteristics of consumer digital cameras are:

- Compact
- Overall pixel count per image of between 1 million to 3 million pixels
- Fixed focus or some form of zoom lens
- Built-in flash
- Extras such as sound and video recording
- Limited manual settings

Some digital cameras also double up as Webcams, which can be used to

send pictures and video over the Internet.

Some mid-range digital cameras to look at include the Canon Powershot G5.

the Minolta Dimage 7i and the Nikon Coolbix 5700.

When looking for mid-range or professional digital cameras it is better to stick

to traditional camera makers such as Kodak, Nikon, FujiFilm, Canon, Olympus, Minolta or Ricoh. This is because they have more experience of producing high quality camera bodies and a wider range of manual controls.

Some professional digital cameras to look at include the FujiFilm FinePix S2 (which

can capture images up to a staggering 12Gb), the Canon EOS-1D and the Kodak DCS 760. With some of these, the camera body and the lenses are sold separately.

Mid-range

Mid-range digital cameras are those that are aimed at serious amateurs that want to have more control over their cameras than they can with a standard consumer one. Some of the general characteristics of mid-range digital cameras are:

- Usually compact but some models have a facility for adding lens attachments to the existing lens
- Higher quality lens and CCD image sensor than found on consumer cameras
- Wider range of zoom lens
- Overall pixel count per image of between 3 million to 5 million pixels
- Wide range of manual controls, such as those for exposure, color adjustment, shutter speed and white balance
- Wider range of file formats for saving images within the camera
- ISO equivalent range of approximately 100–800, or higher in some cases

Professional cameras

These are digital SLR (Single Lens Reflex) cameras that are generally used by professional photographers. Some of the general characteristics of professional digital cameras are:

- Interchangeable lenses
- Top quality lenses and CCD image sensors
- Overall pixel count per image of up to 6 million pixels
- Range of manual controls that is comparable with a traditional film SLR

The functions of a digital camera

Some digital cameras have different design features from standard film cameras. However, many of the functions and elements are similar (this example is a Nikon Coolpix 5700):

Front:

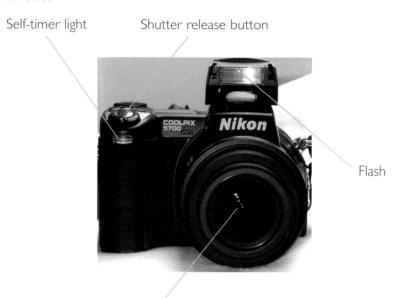

Lens (some models offer a

Some recent digital cameras now have electronic viewfinders which

can contain a lot of image information and even preview the way that a shot will look.

zoom lens, others a fixed lens)

Top:

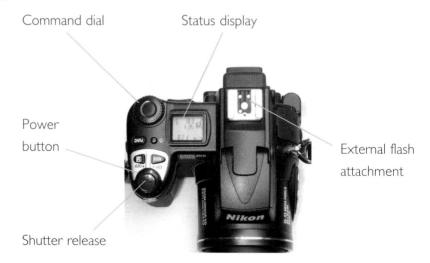

Back:

Some mid-range and professional level digital cameras have some menu

options available in the viewfinder.

As far as the LCD panel is concerned, the bigger the better. This will give you

a good idea of what the final version of the image will look like.

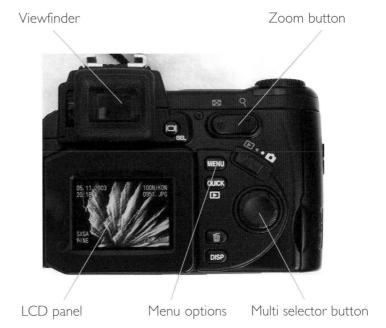

One of the drawbacks of the LCD panel is that it can be hard to view in

strong, direct light. Some cameras overcome this by using a hinge mechanism so that the LCD panel can be flipped out and rotated to get the best angle for viewing.

Side:

Video out connector

DC-IN connector

USB connector

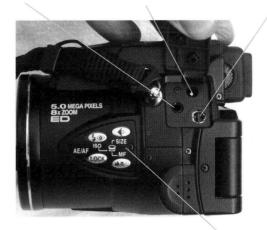

Function options

The workings of a digital camera

The majority of consumer-level digital cameras do not offer a great deal of

flexibility for setting the shutter speed manually. This means it can be difficult if you want to use it for techniques such as capturing fast moving objects by freezing the action.

Although you would need a degree in camera and computer technology to explain every last detail of how a digital camera works, a little basic knowledge can be useful. Some people are interested in what goes on behind the scenes, while for others it is enough that it works when you press the required buttons.

Aperture and shutter speed

The traditional way that cameras have controlled the exposure of an image, i.e. the amount of light that falls onto the film, is to vary the aperture and the shutter speed. The aperture determines how much light gets into the camera, and the shutter speed determines the length of time it has to make an impact on the film. Aperture is measured in f-stops – the smaller the number, i.e. f 2, then the more light that is allowed to pass through the lens.

Shutter speed is measured in fractions of a second. A standard shutter speed is 1/125th of a second, which is the length of time that the shutter is open to allow light to pass through onto the film. Shutter speed and aperture can be combined to give different end results on traditional film.

On a lot of entry-level digital cameras the exposure is determined by the length of time that the diodes on the image sensor are activated for receiving light. Although this differs from the method employed by film cameras, the exposure settings on digital cameras are expressed in f-numbers for aperture and divisions of a second for shutter speeds. These are the equivalent values and this is to ensure uniformity between the two mediums.

When dealing with aperture and shutter speed settings on a digital camera the important points to remember are:

- Although the terminology is technically different, the digital values are given in equivalent terms
- Settings are usually set automatically by the camera unless you change the exposure settings

On some digital cameras the exposure is set automatically so you do not have

to worry about it. However, always try and make sure there is the option to set your own controls if needed.

Camera spec sheets should contain information about their ISO

equivalent ratings. These are usually available from the camera makers' websites and they should also be provided by any retailers selling the camera.

FujiFilm have recently released a range of cameras with a SuperCCD image

sensor. Expect to see more of this type of development in the future.

Film speed

Since digital cameras do not have films they do not have a film speed classification as traditional cameras and films do. This is expressed in terms of an ISO number and is most commonly in the range of 100-400. The film speed denotes how sensitive it is to light – the higher the ISO number then the more sensitive the film. So an ISO 100 film needs a lot of light to capture an image and it could cause problems if you are taking a picture in dimly lit conditions. A film with an ISO rating of 400 is capable of producing images when there are much lower levels of available light. The downside of the film speed equation is that the higher the film speed the grainier the final picture. This is not really an issue when using an ISO rating of 400 but it can become evident if you are using a very fast film, such as an ISO 1600.

In order to help people who are used to ISO numbers and film speeds, digital cameras provide an equivalent for their image sensor's sensitivity. This means it is the film speed it would have if it actually was a film rather than an image sensor. Until recently the most common ISO equivalent for the majority of digital cameras was 100. This meant that the image sensor needed the same lighting condition as an ISO 100 film to perform to its best capabilities. However, this is one area where the technological developments have been considerable. It is now fairly common for consumer digital cameras to have an ISO equivalent rating of 100– 400, while mid-range and professional digital cameras can operate in the ISO equivalent range of 50–1600.

Image sensors

In place of traditional film, a digital camera uses a device known as an image sensor to capture images once the light passes through the lens. In the majority of digital cameras, these are known as a Charge Coupled Device (CCD). A CCD is made up of thousands of photosites that capture colors as the light passes through the lens of the camera. The color is then processed by the CCD and this information is then passed onto the storage medium within the camera. As with most things, different CCDs vary in quality and, in general, the best CCDs are in the most expensive cameras. This is one area that digital imaging companies are developing very enthusiastically at present.

Resolution

Some digital cameras have several resolution settings, including one for capturing

exactly what is seen through the viewfinder. This results in a high resolution but also large files.

If you are buying a camera that has a high overall pixel count (3 million upwards)

make sure that you can still capture images at a setting of 640 x 480. This is because if you are using images on the Web then you will want them to be of a reasonably small size.

The size of a file is set by the number of pixels in it. If it is compressed then

it has less pixels in it and is subsequently smaller.

Although the topic of resolution was touched on in Chapter One it is a subject that can always benefit from a little revision. particularly when you are thinking about buying a digital camera.

Camera resolution

The camera resolution is the number of pixels that a camera is capable of capturing on the image sensor. The headline figure quoted by camera manufacturers will be as a total (1.3 million) or as the pixel dimensions (1280 x 960). Most cameras have at least two settings, so you can have a low resolution (640 x 480) if you only want to display an image on a computer monitor or email it to a friend, or a higher resolution (1280 x 960) for printing images. The higher the overall pixel count a camera has, the greater the number of resolution settings that will be available.

Camera compression

In order to reduce file size, digital cameras can compress images by discarding unnecessary or redundant pixels. This creates smaller files and also results in images with a lower resolution.

Since all digital cameras deal with compression differently it is not possible to give a definitive guide to how this will affect separate systems. One way to judge the compression of comparable cameras is to see how many images they can store on the same memory card at the maximum compression setting. If one model can store more images it means that it creates smaller file sizes but the resolution is not as high.

Resolution, compression and file size

How you use the resolution and compression settings on your camera will determine not only the quality of your images but also the size of the files that you create. For instance, on low compression and high resolution an image could take up 1.5Mb, while on high compression and low resolution the same image may only be 500Kb, or less. Before you start taking pictures it is worth determining what the final image is going to be used for so that you can set your resolution and compression accordingly.

When digital cameras capture images, some of the information in the file size relates to the picture information such as the type of the camera used and data relating to the file format used.

Memory

Memory for storing digital images within a camera comes in two main types:

- On-board memory. This is similar to the memory capacity of a computer's hard drive (although much smaller). The images are stored within the camera and once the memory is full you cannot take any more images until you delete some from the memory or download them to your computer. This is usually now used for cheaper models
- Removable memory. This comes in the form of the discs mentioned in Chapter Two and varies in price according to the size. Removable memory can usually be bought in sizes ranging from 8Mb to over 1Gb

Once a removable memory card is full it can be downloaded onto a computer or replaced by a new one and you can continue shooting.

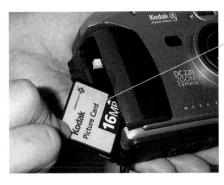

Memory cards are usually inserted into a slot in the side of the camera

As a general guide, an 8Mb card can hold around a dozen images at the

highest resolution and lowest compression, and 80 images at the lowest resolution and highest compression.

It is useful to have a camera that tells you how many images you can cabture on

your memory card or on-board memory. This should change if you change the resolution or compression settings.

The type and amount of memory that you have with your camera is largely dependant on how you intend to use it:

- If you are only going to be taking a few snapshots and will never be far from a computer, then a 8Mb card would be sufficient
- If you are going to be capturing a lot of images in a setting away from your computer (wildlife or travel photography for instance) then you will need a lot of cards with as much memory as possible on them

LCD panel

Once the novelty of using an LCD panel has worn off (and this may be when you have

drained your first set of batteries) create your own guidelines for its use. Try not to use it to review every image that you take, but run through a whole set when you have finished.

If possible, program the relevant settings into your camera through your combuter before you start shooting. This way you will not have to keep changing the settings via the LCD panel.

A large number of digital cameras come fitted with LCD panels and it is an innovation which has considerable advantages, but also a few drawbacks. However, the advantages greatly outweigh the disadvantages and this will undoubtedly become a standard feature on all digital cameras in the near future.

The LCD panel is a small screen at the back of the camera that can be used to review images that have been captured in the camera and change the settings within the camera. This can be very useful for the following reasons:

- You can review pictures that you have just taken and decide whether you want to keep them or not
- You can edit the images in the camera and delete any you do not want, thus freeing up more memory. This is useful if your memory card is full and there are still some shots that you want to capture
- Through dialog menus you can change the resolution, compression, exposure and lighting settings and also add basic effects to your images such as borders. In many ways this replaces the setting controls on a conventional camera

The drawbacks to a LCD panel are:

- It uses up a lot of battery power. When digital camera users mention this in relation to LCD panels they are not talking about days or weeks, but minutes. If you use an LCD panel to review or edit images for much more than 20–30 minutes then you'll soon find that your batteries are running down. This is especially the case if you also use the LCD panel as an additional viewfinder
- It is another piece of delicate technology that has the potential to malfunction
- There is the potential for making mistakes, such as deleting all of your images by accident
- It can be hard to view images in direct sunlight

To save batteries. use a mains AC adapter to review and edit your images

whenever possible.

An additional viewfinder

As well as their reviewing and programming functions, LCD panels can also be used as an additional viewfinder to frame and capture images. If you turn the LCD panel on when you are in picture capture mode you will see a moving image appear in the panel, a bit like a video camera. This is the same (or nearly the same) view as you will see through the standard viewfinder and you can frame your image this way. This can be useful if you want to take close-up pictures of items in inaccessible places.

If the LCD panel is being used as a viewfinder it can sometimes be difficult to see the

image if bright light is falling on the panel. In some cases you may have to move the camera slightly to see the image clearly, but this may then alter the framing of your shot.

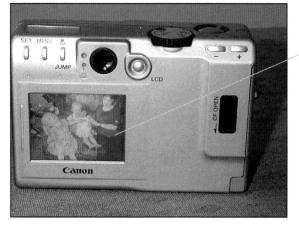

A LCD panel can be used as a viewfinder to take or review pictures

Some recent digital cameras have an LCD panel that can be flipped out and

twisted away from the main camera body. This makes it easier to view images. particularly in strong sunlight. Although using the LCD panel can be useful for specific instances it should not be used as the standard method of framing your images. This is because:

- Using the LCD panel in this way can use up the batteries at an even more alarming rate than reviewing pictures (imagine running a video camera with 4 AA batteries)
- Since the camera is being held away from the face it can be harder to hold it still and the resultant image could be blurry or out of focus. If you practise this technique then you should be able to get to a point when you can usually capture sharp images

However, using the LCD panel as a viewfinder displays a more accurate image of what will be captured by the camera as opposed to the camera viewfinder.

Lenses

When you are investigating the lens of a digital camera, make sure that it is

made out of optical quality glass. On some cheaper models the lenses are made out of plastic.

If you are buying a camera with a zoom lens, make sure that it is an optical zoom

rather than a digital one. An optical zoom is the genuine article, while a digital zoom only enlarges the object in the center of the picture by making the pixels bigger. This is an operation that you could perform equally well with your image editing software.

Fixed focus

As with a large number of compact film cameras, a lot of digital cameras are manufactured with a fixed focal length. This means that the distance from the center of the lens to the film, or image sensor, is fixed at a certain setting. For a lot of "point-and-press" cameras this is usually 35mm, which is a good multi-purpose setting.

With digital cameras the actual focal length is different from the figure that is usually quoted on the box of the camera. This is because, as with aperture and shutter speed terminology, the digital camera companies thought that it was wise to stick to what people already know and so they provide an equivalent focal length figure. So a digital camera that has a 35mm equivalent may only have an actual focal length of approximately 5mm. This is to do with the way the technology of the lens and the image sensor interact. As long as you know the equivalent focal length figure you do not need to know how it is arrived at.

Zoom lenses

As digital cameras are getting more sophisticated so zoom lenses are becoming more common on even the entry-level models. This enables you to view an image with a varying focal length, generally in a range between 35–120mm. This allows you to view subjects at a magnified level without having to move too close to them. In some instances, the zoom lens function will sacrifice the picture quality a little, but it is a useful option to have.

A zoom can change an average image into a more effective one

Flash

Although image sensors need good levels of light to operate well, some

cameras take surprisingly good pictures indoors without a flash, particularly in a well lit room. Keep an eye out for the artificial light affecting the naturalness of the colors in your image though.

The first thing to say about flashes on digital cameras is that you will not be stunned by their remarkably high power. This is one area that seems to have been left behind a little in the digital revolution, as the pressure to improve other areas has intensified. Most flashes on digital cameras in the low-to-middle end of the market are not particularly powerful and only useful for basic flash work. If you rely heavily on a flash then you will have to splash out on a higher specification model.

Flash can make the difference between a vibrant image and a dull one

Red-eve reduction with flashes can be a bit of a hit and miss affair. It

a more natural look but it does not always work and it can be disconcerting for the person being photographed.

can give the eyes

Digital flashes often come with a number of settings:

- Auto. The most straightforward flash setting on a digital camera is Auto. This means the camera decides whether there is enough light for the shot and activates the flash if conditions are too dark. This can be useful if you have misjudged the amount of available light but it can be annoying if you were not intending to use a flash
- Off. This turns off the flash completely
- On. This fires the flash with every shot, regardless of the lighting conditions
- Red-eye reduction. This fires the flash before the picture is taken and again when it is captured

Batteries

Battery usage has traditionally been a big problem with digital cameras.

However, manufacturers have been addressing the problem and the situation is improving with most models. One of the best performers in this respect is the Mavica from Sony, which can operate for approximately an hour on one set of batteries. When digital cameras first appeared on the scene, battery manufacturers must have started to rub their hands in gleeful anticipation. Digital cameras use a lot of battery power. And if you are using the LCD panel you can almost see the power draining away before your eyes.

Battery usage

The best news about batteries and digital cameras is that there is an accepted standard for the type that is used – the AA. In some cameras you can use lithium batteries, which last two or three times longer than standard alkaline batteries. Check when you are buying a camera what types of batteries it takes and how many images (roughly) they will be able to capture per set. There are also a few general guidelines that can be applied:

- Take the batteries out of the camera if it is inactive for long periods of time
- Replace sets of batteries in their entirety. Do not just replace two batteries out of a set of four
- Do not mix alkaline batteries with other types

Rechargeable batteries

Considering how quickly standard alkaline batteries can be used up by a digital camera, it is reasonable to say that rechargeable batteries are a necessity rather than an optional extra. These usually come in the form of NiCad or NiMH batteries. Some cameras come with a battery charger and rechargeable batteries and this is one of the most useful accessories you can get.

Look for cameras that have a display that tells you how much life there is left in

your batteries. This can save you from being caught out if your batteries pack up without warning.

Some newer digital cameras use rechargeable lithium batteries as their power

supply. These are an excellent option as they last longer than either the NiCad or NiMH varieties.

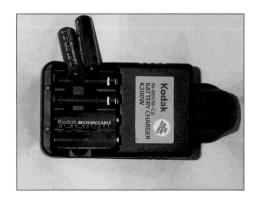

A battery charger and rechargeable batteries will more than pay for themselves in the long run. Go for NiMH batteries if possible

Additional features

TV playback

One useful feature on a digital camera is the ability to show images via a television screen. This way you can set up your own slide shows for friends and relatives without having to worry about projectors or screens.

Different cameras have different additional features. It is best to decide first

which ones you want and then try to find a camera that satisfies these needs.

If your camera supports this function, you can set up a television playback display by selecting the relevant mode on your LCD panel and then inserting a video cable into the camera and your television. Then, when you press the relevant Start button on the camera, your images will appear on the screen.

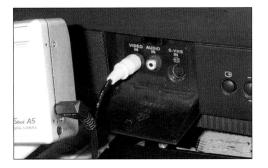

By cabling your digital camera into a television, it is possible to view your images in your living room

Digital images contain information that is used within the camera itself and

also in image-editing software. This information relates to areas such as file formats and the type of camera used when capturing an image.

Although the user never sees this information, it is very important for the processing of digital images.

Image information

Via the LCD panel it is also possible to view information about individual images, in much the same way as you would with files on a computer. The type of information that is available for each image is:

- File name. The individual name of each image
- Date and time of capture. This can also be displayed on the final image, if desired
- Aperture setting. Displays the equivalent f-stop number for each image
- Shutter speed. Displays the equivalent shutter speed for each image
- Flash details. Displays the type of flash that was used for each image

Camera software

When you link ub vour camera and computer, error messages can appear for

a variety of reasons:

- the camera is not connected properly
- · the camera is not turned on
- you have more than one type of the system software running

Make sure that the system software supplied with the camera is compatible with

your computer. Most cameras are designed to work on PCs or Macs, but sometimes the latter require extra connection cables. When you are assessing digital cameras it is important to keep an eye on the software with which they are supplied. This usually consists of two types: system software and imaging software.

Camera to computer communication

The software linking the camera to the computer is an integral part of the camera itself - without it you will not be able to transfer your images to a computer. It will almost certainly come on a CD and the manual will include full installation instructions. What the camera software does is allow the camera and the computer to communicate with each other. Once this channel of communication is established you will be able to do several things:

- Download your images onto your computer
- Catalog and edit your chosen images
- Change the settings on your camera

Windows XP and Mac OS X

Both of the latest Microsoft and Apple operating systems are designed with digital camera users in mind. Both of them have software for the most commonly used digital cameras already preinstalled. This means that when you connect a camera, the operating system will recognize it and supply the appropriate software, known as a driver. If the operating system does not recognize the camera then you will be given the option of loading the camera software manually from a disc, usually a CD:

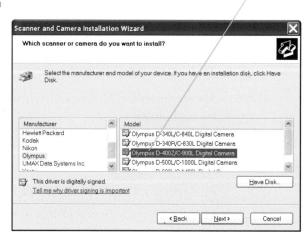

Image editing software

The type of imaging software that you get with your camera will depend on three factors:

- The camera manufacturer
- The retailer
- Your ability to haggle

The minimum you should be looking for in terms of software is a medium-range editing program such as Adobe Photoshop Elements or Ulead Photo Express. In some cases you may also need additional utilities for tasks such as image cataloging and Web authoring. Shop around to see what is on offer in different outlets. It may be possible to negotiate different deals.

Programs like Adobe Photoshop Elements (sold with a lot of digital cameras) are an excellent option in terms of price and functionality:

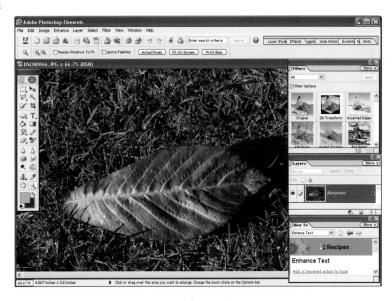

It is an unfortunate fact that some retailers who sell digital cameras do not know enough about them. If you feel you have not had satisfactory service, then look elsewhere.

At present, only a few cameras come with Web page authoring software.

However, this is an area that is certain to expand. So look out for more of these types of programs becoming available as part of the digital camera package.

For a more detailed look at image editing software and what it can do.

see Chapters Seven and Eight.

Other ways to obtain digital images

Make sure your scanner comes with TWAIN compliant software. This is a

computing language that enables devices such as digital cameras and scanners to communicate with image editing programs. This means your image editing program can open your images directly from your camera, once it has been connected to the computer. Most editing software these days is TWAIN compliant.

If you are scanning an image for use on the Web, set the output resolution

to 72 pixels per inch (ppi). If you are scanning it to be printed out, set the output resolution to between 150-300 ppi, or above. These settings for images can also be changed in an image editing program once the image has been scanned, but it is better to get it right at the scanning stage if possible.

Obtaining digital images is not just a question of doing so with an expensive camera. There are a variety of other methods for getting images onto your computer:

Scanners

There is a huge variety of scanners on the market and they cover a wide range of types and prices. In some ways, scanners can be thought of as static digital cameras: the images have to be brought to them rather than taking the camera to the image. However, their basic function is similar – to create digital images. When an image is scanned both the image resolution and the output size can be set and this in turn determines the overall file size of the scanned image. Unless you are interested in investing tens of thousands of pounds on a unit that would have the power to launch a space shuttle the main options available are:

Flatbed scanner. This is the most common type widely available and the costs have fallen dramatically in recent years. Most of these scanners can copy a letter-size image or smaller and they operate in much the same way as a standard photocopier: the image is placed on a glass plate and then a light source is passed over it and the reflective image is captured by a Charge Coupled Device (CCD). The image can then be manipulated on a computer in the same way as one captured by a digital camera. The resolution of flatbed scanners is measured in dots per inch (dpi) and for a high quality scan you will be looking at a device with at least 1200 dpi.

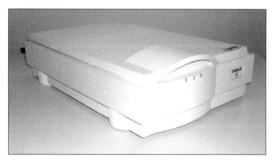

Flatbed scanners are cheap, versatile and produce excellent images

Some flatbed scanners come with adapters for scanning 35mm transparencies.

These are in the form of a small box that clips onto the side of the scanner. This is a very useful addition if you have a reasonable number of transparencies that you want to digitize. Scanners with these adapters are more expensive but it could be a worthwhile investment.

Sheet feed scanners. These are scanners that allow for a letter-size sheet, or smaller to be passed through the device in much the same way as a fax machine. Although not as versatile as flatbed scanners they are a useful option if you just want to scan letter-size or smaller. Some scanners combine both the flatbed and sheet feed options within the same model. These are more expensive than those with a single option, but they are more versatile

A combined flatbed and sheet feed scanner. where the image can be fed into the scanner through a paper tray

35mm film scanners. This could be an essential option if you have a large quantity of slide transparencies that you want to add to your digital collection. These have an adapter into which you place the transparency and which you then place into the scanner. These scanners are more expensive than flatbed ones and have a resolution from approximately 1200 dpi to 2750 dpi

Photo CDs

These are CDs that are capable of holding up to 650Mb worth of digital images. These can be purchased with images already on them. The size of these images varies, up to approximately 2000 x 3000 pixels. This is good for printed output but it does produce large files that take a long time to process.

The World Wide Web

The Web is an excellent resource for finding images. Any image on the Web can be downloaded (select it with a right mouse click (PC) or Control+click (Mac) and then save it to your computer). There is also a variety of digital image libraries (a lot of them on the websites of camera companies such as Kodak and Olympus).

Be careful not to infringe copyright when you are downloading Web images. In theory,

these have the same restrictions as hard copy images.

Digital camera checklist

To summarize, bear in mind the following points when you are considering which digital camera to buy:

- Decide what you want it for: Web publishing, hard copy prints or both
- Web images do not require to be as large as those that are going to be printed
- The size of images is determined by the number of pixels that a digital camera can capture. Most cameras on the market today can capture a minimum of 1 million pixels. This is also known as the megapixel value of a camera. If images are going to be printed, then a camera with a higher pixel count is best. For Web publishing, a camera with a lower pixel count can be used as very large images should not be used on websites due to their download time
- Look for the "effective" pixel count of a digital camera, not just the headline figure. The effective figure is less than the headline one because cameras use a proportion of the pixel count for calibration and processing images
- Decide what type of memory you want: it will probably be a choice between CompactFlash and SmartMedia
- Decide how you want to download your pictures to your computer. This can be done by cables or card readers, such as the SanDisk. With operating systems such as Windows XP and Mac OS X and a USB cable connection, images can be downloaded very quickly and there is no need for additional software
- Battery life is a vital issue for digital cameras. Check the battery life of different models. Make sure you use rechargeable batteries and a battery charger
- Look for a camera with a glass lens rather than a plastic one
- Look for a camera with an optical zoom lens rather than a digital. An optical zoom is an actual zoom; a digital one just crops the image in the viewfinder and then adds more pixels by guesswork

Capturing digital images

Although some aspects of capturing an image with a digital camera are the same as with a film camera, there are some areas that are unique to the digital variety. This chapter looks at the best ways to create digital images and also some of the uses to which they can be put.

Covers

Through the viewfinder 64
Focusing 65
Exposure 66
Using light 67
Depth of field 70
Landscapes and landmarks 72
Buildings 74
People 75
Children 77
Business applications 79
Composition matters 80

Chapter Four

Through the viewfinder

Viewfinders on digital cameras tend to have less information in them than

film ones.

A viewfinder on a digital camera is very similar to one on a standard point-and-press camera. This means that, since it is positioned away from the lens of the camera, it views the subject from a slightly different angle. This can cause a problem known as parallax, which means that everything you see through the viewfinder will not be captured through the lens. To overcome this potential hazard, there will usually be marks around the edges of the frame which indicate the area that is going to be seen by the lens. It is important to pay attention to these marks or else it could result in parts of your image being cut off.

This image was correctly framed in the viewfinder but, due to parallax, it is badly positioned when captured through the lens. This problem is more pronounced with close-ups

The closer you get to a subject then the greater the danger of having a part of

the picture cut off. Tops of heads are particularly at risk from this problem.

To ensure a subject is viewed correctly by the lens, it may be necessary to place it off-center in the viewfinder

One way to get around this problem is to use the LCD panel to frame your images, since this is the same view as the one the lens sees. However, as shown in Chapter Three, there are drawbacks to this, the principal one being that it can be hard to get as sharp a picture when the camera is held at arm's length.

Some mid-range and professional digital cameras now capture images exactly as they are seen through the viewfinder.

Focusing

Anyone who has ever fiddled with the focus controls on a manual focus camera will appreciate the advances that have been made in this area in recent years and the options that are now available. Manual focusing is available on the more sophisticated models of digital camera, but the standard ones have two main settings: fixed focus or autofocus

Fixed focus

As the name suggests this is a focusing system that is fixed in place and cannot be altered. Everything within a certain range will be in focus and anything outside the range will not. The settings are generally from approximately 1 meter to infinity. This is fine if you are taking general or landscape shots but not so good if you want to do a lot of close-up work.

Autofocus

This is an increasingly popular system whereby the camera focuses automatically on the subject in the viewfinder. It does this by using light beams to measure the distance between the lens and the subject and then selects the focus accordingly.

In order for autofocus to work the user has to give the camera a helping hand. This is done by half depressing the shutter button and then waiting until the camera focuses on the subject. Once it has done this a light will appear or the camera will beep. You then proceed by fully depressing the shutter button. One of the drawbacks with autofocus is that it can have problems in low level lighting, when there is very little contrast within the image on which it is trying to focus.

Special settings

Some cameras offer special setting such as Infinity or Close-up for occasions when you may want to capture particular types of images. This sets the camera's focus to certain levels (for instance, the close-up setting may be in the range of 0.25–0.5 meters) and also sets the appropriate levels of flash. Although this can be useful for certain types of shots it can be a bit limiting too: if your subject is just out of the range of focus then you would have to reposition yourself since the focus cannot be altered from the set levels. The infinity setting will probably be used less frequently than the closeup one.

With an autofocus camera it is possible to lock the focus on a certain point

and then reposition the camera to capture an image. This is done by framing the subject. activating the autofocus, and then, with the shutter button still half depressed, repositioning the camera for the shot.

If you are worried that low level lighting will cause problems with autofocusing, take

some test shots first and then preview the results. If this is going to be a problem, try to introduce an additional light source into the shot.

Exposure

Some cameras allow for exposure compensation. This means the user can adjust

the exposure by the equivalent of +2 or -2 in f-stops. This is particularly useful if your images are under- or overexposed. If vour bictures are too dark then increase the number and if they are too bright, decrease it.

Although a lot of digital cameras automatically set the exposure (the combination of shutter speed and aperture settings that determines the amount of light falling on the image sensor), there are usually options to determine how this calculation is arrived at. With the increasing development of cameras currently on the market, it is becoming more common for all ranges of cameras to have at least some type of manual exposure settings.

Spot metering

This is where the camera takes a light reading from the subject in the center of the lens and makes the exposure setting accordingly. This can be useful if you are capturing an image against a very light background. Since the exposure is being taken from the center of the frame it should be correctly exposed and therefore balanced with the brighter background.

Center-weighted metering

This is similar to spot metering in that it takes the main light reading from the subject in the center of the image. However, it also measures the light around the edges of the image too, although it still gives prominence to the center.

Multi-pattern metering

This method arrives at an exposure reading by measuring the amount of light in the whole image, not just the center. This is similar to putting a grid over the image and taking light readings from each individual cell. This is probably the best setting for general use, but in the above example it would result in the subject in the center being underexposed.

Experimenting with settings

The majority of digital cameras have default exposure settings which usually involve a multi-pattern reading. It is perfectly feasible to take all of your digital photographs without ever changing the exposure settings, and you will probably achieve good results. However, it is a good idea to experiment with the various exposure settings on your camera. This will give you more options when you are capturing images and it may come in useful if you are ever in a situation that requires a particular exposure setting because of the lighting conditions.

When you first get a digital camera, experiment with the exposure

settings. You will be able to see the results immediately and get to know the effects it produces. This will make you more confident when you are taking shots that really matter.

Using light

Since image sensors have an equivalent ISO rating of 100 (i.e. they need a reasonable amount of light to function effectively) it is sometimes necessary to use a little finesse when capturing images in dimly or very brightly lit circumstances.

Shooting in low light

If you are faced with capturing a digital image under poor lighting conditions there are a number of options:

- Come back when the light has improved
- Take the shot and hope that you can edit the image sufficiently with your image editing software
- Use flash if the subject is within range
- Try to use an additional light source
- Increase the exposure setting by one or two f-stop equivalents:

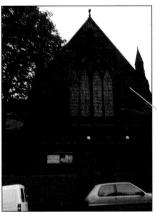

This image was captured at dusk, using the available light, and is too dark

same time as the one above, but with the exposure setting at +2, and is therefore much clearer

If you are a perfectionist who always wants to have the optimum lighting

conditions then you could be in for a long wait on occasions.

Some photographers have been known to wait for weeks to get

the perfect light. At least with image editing software there is now an alternative if you do not have time on your hands.

As digital cameras are becoming more advanced, they are becoming

much better at dealing with difficult lighting conditions. This is particularly true of mid-range and professional models, some of which are approaching the standards of their film counterparts.

Adjusting lighting problems

Although light is usually the digital photographer's friend, there can be occasions when there is either too much light or it is coming from the wrong place. One instance of the latter is if there is one small area of light that is a lot brighter than the rest of the image. This could be sunlight reflecting on a window or a burning match. The result is that a *hotspot* appears in the final image i.e. an area where the amount of light has created a bright, white blur. It is possible to try and rectify this by adjusting the exposure but the three most effective remedies are:

- Reposition yourself so that the bright light is not in the image
- Wait until the sun moves position slightly so that the glare is not so pronounced, or has disappeared completely
- Use something to shade the offending items out of the image. This could be something as simple as holding up your hand to cover the glare from reflected sunlight

White balance is the term given to remedying indoor lighting problems. This will often be

referred to in relation to Fluorescent and Tungsten controls.

The light reflecting in the doorway has created a hotspot

Another problem area with lighting can be if you are capturing images indoors without a flash. This can result in the image taking on a green or reddish-orange tint, depending on the type of indoor lighting. Some cameras let you adjust this so that your images have a more natural appearance. Look out for white balance controls, which are the ones that correct the green or reddish-orange tints.

Fill-in flash

If you are capturing images on a bright sunny day you may think you have the ideal shooting conditions. However, there is one stumbling block that can occur under these circumstances and this is called backlighting. This happens when you are capturing an image, usually of people, when they have their back to the sun, resulting in their face and front being in shadow. The subsequent image can be unsatisfactory, as it appears to be a bright sunny day in the background and yet the subject looks dull and uninspiring.

There are a few ways to deal with backlighting:

- Ask the subject to move so that the light source is facing them
- Increase the exposure on your camera
- Use fill-in flash to make your subject as bright as the background

The option of fill-in flash is probably the most effective for rectifying backlighting problems. One point to remember is that you may have to turn the flash on, rather than relying on the camera to shoot it automatically: if it is a bright day it may calculate that a flash is not required.

When using fill-in flash, make sure vou are reasonably close to your subject.

Otherwise the flash will not be powerful enough to brighten up the areas of shadow.

Photoshop Elements, the latest image editing program from Adobe, has

a function for adding fill-in flash to parts of images once they have been taken and downloaded onto a computer.

To improve the image, add fill-in flash to give it a more even look

When shooting into the sun the subject's face can appear in shadow

Depth of field

The depth of field in an image is the area in front of and behind the subject that remains in focus. Depth of field is an important consideration if you want to have a subject that is sharply in focus while the background is blurred:

If you want to create an image with a blurred background and you cannot

generate this through depth of field, then a similar effect can be achieved with image editing software. The main subject can be isolated from the rest of the image and then a blurring or softening effect can be added to the background.

In some images a distracting background can take attention away from the main subject of the image

By decreasing the depth of field the background becomes out of focus and less prominent. This can be done by using a wider aperture setting, if the camera allows

This can be an effective technique because it gives more prominence to the main subject in the image. If the image is captured with a larger depth of field then the main subject gets slightly lost in the background. This can be particularly distracting if the background is multi-colored or it contains numerous different items.

Depth of field can be changed by moving the subject in relation to the background. A few digital cameras currently on the market offer settings that can affect the depth of field. However, most of them do not and it is a case of experimentation and improvisation. This is undoubtedly one area that will improve as digital cameras develop.

Depth of field is also affected by the type of lens being used. A telephoto lens

has a much lower depth of field (less of the area will be in focus) while a wide-angle lens creates a greater depth of field.

If you achieve a depth of field effect that you particularly like. check the

exposure at which the image was captured (this can usually be done through the image information control on the LCD menu). This may help you to recreate the effect in the future. Depth of field is altered by changing the aperture setting on a camera: the wider the aperture then the less the depth of field i.e. the area of the image that remains in focus is reduced. However, since a lot of digital cameras currently on the market do not allow for manual changes to the aperture, the best way to change the depth of field is to move your subject so that there is a greater distance between it and the background. Either that, or move yourself.

Altering the depth of field with digital cameras works best with close-up shots, when there is a reasonable distance between the subject and the background.

When you are capturing landscape shots, one consideration for depth of field is when you want to capture a foreground element in focus and the background features. To achieve this you may have to experiment with capturing the image from different viewpoints, unless you can move any of the elements of the image. The focal length of a lot of digital cameras allow for a large depth of field to be captured and so it is usually reasonably easy to keep the foreground and the background in focus.

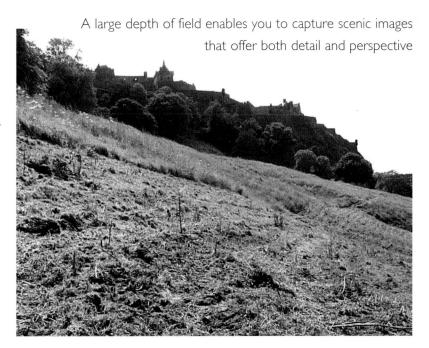

Landscapes and landmarks

If you are travelling abroad with your digital camera, make sure you know

the voltage of the power supply in the country you are visiting. Find out if you need an adapter and take one with you rather than relying on getting one when you arrive.

Landmarks

When capturing landmarks, whether they are international, national or local, the first thing to remember is that they have probably been photographed thousands of times before. We have all seen picture-postcard shots of the Statue of Liberty or the Eiffel Tower. If you are capturing an image of a famous building or statue, bear in mind what has gone before and try and be a little bit different.

One way this type of image can be given an extra dimension is to capture it from an unusual angle. Instead of standing face on to your subject, look at it from above or below to get a new perspective. It may take a little more time than a standard shot but it will be worth the effort. Otherwise you might as well buy a postcard.

Another way to liven up a landmark shot is to have another object of interest in the picture. Sometimes this may depend on luck – if a hot air balloon floats past as you are capturing the Leaning Tower of Pisa – or else you can be creative and add your own props. This could be in the form of an object or a person. Use your imagination but do not do anything that may harm the object you are capturing. You could include items such as:

- A colorful piece of material placed in an image with subdued colors – such as a red handkerchief placed in the hand of a statue
- Items such as flowers or flags
- Other people interesting-looking people can make great props next to landmarks

If you are going to be away from home and intend capturing a lot of images, consider

the security of your full memory cards. Either send them back home or store them as securely as you would your passport.

The best lighting conditions for photography are usually first thing in the morning

and early evening. Always consider the quantity and quality of light when you are capturing images.

If you are there, a glistening mountain range or a stunning sunset can be a wonderful sight. If this is then captured on a digital camera it can result in an excellent image. However, if you are displaying your holiday snaps, one shot of a beautiful sunset can be dramatic but a dozen can become tedious.

It is a fact of life that we all like to see images with people in them, even if it is people we do not know. They add perspective and meaning to an image, particularly if it involves another country or another culture.

If you are taking landscape shots try to include an object, animal or person that can act as the focus of attention in the image. This could take a number of forms:

- A climber on a mountain ridge. In instances like this, make sure that the person or object is of a sufficient size in the image to be seen properly
- A boat in front of an evening sunset. Try getting the boat silhouetted by the setting sun
- A fisherman on a deserted lake. If he or she is in the process of actually catching a fish then so much the better
- A child playing with a ball on a beach
- A single sheep in a vast field of grass
- A car driving along a dirt track, with a plume of dust rising behind it

If you make the object the center of attention in your image this will give it added impact and also serve to emphasis the natural beauty of the scenery. However, this does not mean that you have to position your object in the actual center of the image. An offcenter object frequently improves the composition of an image and this is known as the rule of thirds (see page 81). Also, you can use the object to draw the eye into other areas of the image that might otherwise be overlooked.

If you are impatient you may get a picture but it will not be the best possible

one. Be prepared to wait until a suitable object appears in your image or your subject does something out of the ordinary.

Buildings

If you cannot stand far enough back to capture the whole of a building you will

have to use a wide angle lens. If you have a fixed lens then you will have no choice but to try and take the shot from a different angle.

A standard view of a building provides a traditional, if somewhat predictable, image

Interior shots of a house can be used to catalog items for insurance

purposes or to assess the layout for redecorating purposes. It is even possible to use image editing software to experiment with how different colors would look in the interior.

When you are capturing interior shots, be conscious of different light sources in your

image. One may be natural light, another fluorescent light and a third tungsten light. This could affect the color balance of the final image.

Looking at the building from a different angle gives the image a much greater impact

One of the most important factors when capturing the exteriors of buildings is perspective. This can affect a shot of a building where the straight lines of the subject seem to merge together (also known as converging parallels). This happens most frequently with tall buildings and the best way to avoid it is not to tilt the camera when you are trying to fit in the whole of a tall building. Having said that, there can be circumstances when this gives an interesting artistic effect.

Images of the interiors of buildings can also be effective. One of the major considerations here is the amount of available light, as the use of flash may not be possible.

People

Even if you are happy with a group shot once you have viewed it on the LCD

panel, take a couple more to be on the safe side. It is not always possible to see all of the detail and there may be a blemish that is only visible when the image is viewed on a computer monitor.

Group shots

The greatest problem in capturing groups of people is that at least one person is always blinking or looking in the wrong direction when the picture is taken. With traditional film this does not become evident until the developing process has been completed. However, with a digital camera this can be spotted immediately, via the LCD panel, and another shot taken.

When you are photographing a group of people take a few shots and let everyone see the images on the LCD panel. They will then know how they look in the image and make any adjustments that they see fit.

Rather than having a static group of people staring at the camera it is always a good idea to arrange people in a variety of positions (standing, sitting, kneeling and even lying down) or ask them to position themselves around an additional object, such as a bench or a car. This will create an image that is more original - plus it will be more fun preparing the shot.

You can include yourself in a group shot if vour camera has a self-timer

option. However, these shots frequently look a bit unnatural, as everyone is staring at the camera wondering when the shutter is going to go off. Take two or three shots like this, so that everyone can get used to the method.

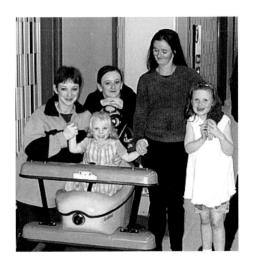

This group shot is made interesting by the composition of the people and the way they are arranged around the children's toy airplane

If you want to take a portrait of someone. give them a reasonable

amount of advanced warning. Tell them where you want to capture the image (inside or outside) and if you would like them to wear a particular item of clothing. This will give them the chance to prepare themselves and so they will feel more relaxed.

Portraits

Since a large number of digital cameras only have the equivalent of a fixed focus 35mm lens, close up portraits are not always possible. Some models do have zoom lenses (up to about the equivalent of 120mm focal length) and these should be considered if you want to take a lot of portraits.

A zoom lens can make all the difference when you are capturing portraits of people. Look for a camera that has this facility

If you take a lot of sporting images and want to produce these digitally then, at

present, you would be best served by a good quality SLR film camera and a scanner. This will change as the digital technology improves but this is the position at present.

If you want an action portrait of someone then your options are more limited than with conventional cameras. This is because a digital camera's recycling time is longer than that of its film counterpart. This means it takes longer for the camera to be ready from one shot to the next. With a film camera this could be less than half a second (and in some cases much less) while with the majority of digital cameras the figure is in the range of two to five seconds. This puts considerable restraints on capturing consecutive shots of people engaged in action situations. Some mid range models do have a burst facility which takes several pictures in succession but their present quality is such that they cannot be relied upon for genuinely fast action shots.

Children

Portraits

Children can be both a joy and a menace to capture with a digital camera. They love the immediacy of seeing themselves on a mini screen seconds after the image is taken. This can result in them wanting to become more involved in the photographic process, which can have its advantages and disadvantages.

Children love digital cameras because they can see the images

immediately. However, be careful about handing them over into little hands.

The most common images of children, and the ones most likely to adorn the mantelpieces of parents and grandparents, are the faceon portraits with the child looking directly at the camera. With a little planning these can be made to look even more appealing than usual:

- Take the image against a neutral background. Children are invariably surrounded by the clutter of their busy lives and while this is a useful way to keep them occupied, it can detract from a staged portrait
- Move down to their level. This will make them feel more comfortable and also result in an image in which they are not staring up at the camera. Relaxed-looking pictures of children are frequently the most effective

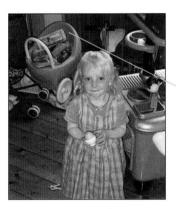

This image has a distracting background that detracts from the subject

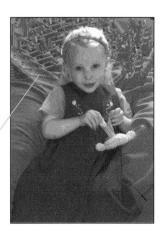

If you are taking images of children in swimming pools, using the LCD

panel to frame the image is a good way to get an effective shot without having to physically get too close to the water. This can create the impression that you too were in the water when the image was captured.

Activities

Another popular way to capture images of children is to do so when they are engaged in a particular activity. This shows them in their natural environment, when their attention is diverted away from the camera. Some areas to consider for this are:

- Playgrounds
- Swimming pools
- Soft play areas
- Zoos or animal parks where the children are allowed to touch and ride on the animals
- Sporting events, such as school sports day

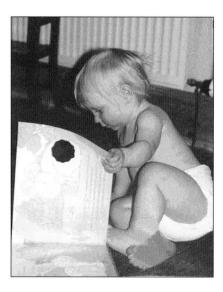

A good technique for capturing images of children is to do so when they are occupied or involved with an activity such as reading

Children do not always do exactly what you expect when you are photographing

them. Be patient and be prepared to take a lot of shots to get the one you want.

> Children's natural propensity for perpetual motion can sometimes cause a few problems when you are trying to capture an image with them performing a certain activity. If you are trying to catch an active child running or throwing a ball the result can be blurry and out of focus. To avoid this, try capturing these images under good lighting conditions so the shutter speed is as fast as possible and so there will be less time for the image to blur.

Business applications

If you have to take an image of a group of people in a workplace it is a good idea to

talk to them beforehand to see how they think the picture should be bosed. This is a good way of generating ideas and it will put everyone in a more relaxed mood for when it comes to capturing the image itself.

Another productive use for digital images is in the business world: the price of the equipment is not such an issue as with the private user and the means for using the images is usually in place. The two main outlets for digital images in the workplace are on a Web page (a corporate Internet page or local intranet one) or in an office publication such as a magazine or a newsletter.

Capturing groups

One of the most common, and most uninspiring, office images is the one of a group of people standing in a line and staring at the camera. It may be illustrating the personnel in one division of the organization or it may be a group of people who have won the sales people of the month award.

If you are given the job of capturing a group like this then try and liven it up a bit: rearrange them so they are not in a straight line; give them all something to hold; or ask them all to throw their arms in the air. Be innovative or else it will just be another standard, unimaginative image.

Chief Executive Officer (CEO)

Closely following the group photograph in terms of a potentially uninspiring approach is the image of the CEO seated regally behind a desk. This may be as part of an introduction to a newsletter or on the Web home page but it is an image that has been seen thousands of times before. Try and be creative with this type of image: put the CEO in a different situation (in amongst the workforce for instance) or get him or her in a more relaxed pose.

Using business images

When you come to use your business images there are a few rules that should be followed:

- Make sure people are looking into the page or screen, rather than away from it off the edge
- Use images of people being active rather than sitting staring blankly at the camera
- Don't compromise on quality

Always tell your colleagues what you are going to use the images for. Some people

are very reticent about having their picture displayed around the office, so a bit of sensitivity is sometimes required.

Composition matters

Background considerations

With film photography, some of the best shots of people can be ruined by unwanted objects in the background. These can include:

- Telephone or telegraph poles
- Objects such as plants or flowers that seem to be "growing" out of the top of the subject's head
- Other people who may inadvertently get in the shot

Fortunately, thanks to image editing software this is not a problem for digital photography. The images can either be removed or else the background can be softened so that they are no longer visible. However, if this problem can be avoided in the first place then it saves one extra task when it comes to the editing. This not only makes for a more genuine picture, it also removes the need to do a lot of editing to an image, which can result in a deterioration of quality.

If you capture a shot that has an unusual or unwanted background

element this can be used as a humorous image at a later date. For instance, a bridegroom who is captured with a bouquet appearing from the top of his head may see the funny side of it – but only after the traditional pictures have been delivered.

Keep an eye out for distracting background objects, although sometimes they can be used to create an unusual or humorous effect

Sometimes background elements can be deliberately incorporated into an image. This usually involves a certain amount of preplanning or a large degree of luck. If you have a particular image in mind then try and arrange the necessary props. There was one famous image of this type when a soccer manager was standing in front of the club logo, which had two black triangles at either side. The image of the manager appeared in the press with the triangles behind him, giving him an uncanny resemblance to Batman.

It is possible to have an image that is perfectly composed with the main subject

in the middle of the shot. However, if you apply the rule of thirds it can give you a lot more flexibility when you are composing your shots.

Using a grid

As mentioned earlier it can improve an image to have the main subject out of the center of the image. This can give it a more natural appearance and make it look less posed. However, it is not just a case of positioning the subject anywhere out of the center of the image, which could result in an unbalanced picture. Imagine your image as a grid of 3 x 3 squares and position your subject at the intersection point of any of the grid lines. This should provide you with an eye-catching and balanced composition.

This is known as the *rule of thirds* and it can be applied to give an image a completely different perspective. Always keep this in mind when you are capturing images and place the subject in different areas of the rule of thirds grid. Due to the versatility of digital cameras, it is possible to use this technique and instantly review the results to see how repositioning the main subject can alter the final image.

These are two images of the same subject, taken one after the other...

The horizon in an image can also be composed using the rule of thirds. Try

positioning it in the top or bottom third of the grid, to see what effect this has on the image.

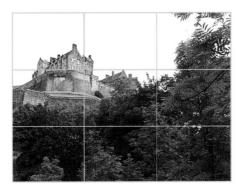

By applying the rule of thirds, two dramatically different images have been created

Composing with natural elements

When you are composing shots, the natural elements that are available can be incorporated into the final image. Some ways that this can be done are:

Using natural objects to frame a subject. This is similar to putting the image in a frame once it has been captured. However, if the frame occurs naturally then this gives the image extra relevance

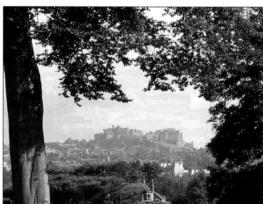

Trees and bushes are excellent for creating natural borders around a subject

The natural space in an image. Do not underestimate the value of space in an image. It can be used to emphasis the vastness of a scene and give the subject a chance to express itself. This is often referred to as negative space and this should be kept in mind, particularly when capturing large objects. Do not just look at the subject of an image; give some consideration to the space around it and how this will affect the composition of the image

It is perfectly acceptable to break the rules of composition and achieve dramatic

results. However, it is best to get the hang of the basics first:

- · Capture some images using the rule of thirds and utilizing negative space
- · Look at the results and see what similar scenes look like if you ignore these rules or apply the opposite

As you do this you may even develop your own rules of composition.

Arches are an excellent option for framing elements of an image. They can

either be used as a black silhouette (usually by editing them with image editing software) or they can retain their natural color to add texture to the framed image.

Using Windows XP

The latest edition of Microsoft's operating system, Windows XP, is designed to make working with digital images as easy as possible. This chapter shows how to get the most out of XP and harness its considerable capabilities for improving the digital imaging process.

Covers

DOWN	loading	images	84
DOWN	loading	iiiiages	0 1

Adding digital devices | 88

Viewing images | 91

Editing and printing | 97

Chapter Five

Downloading images

The minimum requirements for using Windows XP are:

- Pentium, or equivalent, 233 MHz or higher processor
- · 128Mb of RAM
- VGA resolution or better monitor
- CD-ROM or DVD-ROM drive
- 1.5Gb hard drive space for installation

To make full use of all of the features of XP it is also desirable to have items such as a 56Kbps modem, a sound card and speakers.

If XP does not recognize your camera, then it can be added as a new digital

device. See pages 88-90 for details on how to do this.

Windows XP is the latest version of Microsoft's operating system and is the successor to programs such as Windows 95, 98, 2000 and Me. XP is proof, if it were needed, that digital imaging has now reached the point where it is likely to achieve mass market status. XP has a number of features that are designed with the digital photographer in mind. The program helps to simplify the process of downloading and manipulating images and this is an element that has featured heavily in Microsoft's promotion of the product. From the digital photographer's point-of-view, XP is an excellent addition to the equation as it helps to take some of the wrinkles out of parts of the digital process.

Adding images with XP

XP recognizes a lot of digital image devices automatically and displays their details as soon as they are connected. However, in some cases you may need to install the camera software manually. Once this has been done, you can start downloading images. If you have more than one device available, this can be done as follows:

- Turn on your digital camera at the correct setting (e.g. Connect) and connect it to your computer
- XP automatically recognizes the type of camera

The required camera software is automatically installed

5 Check on the boxes to select images or click Select All

Click here to change the orientation of selected images before they are

6 Click on Next

When images are downloaded, they are all numbered sequentially, using the folder name

that is created in Step 7.

By default, images are downloaded to the My Pictures folder. However,

this can be changed by clicking on the Browse button and selecting the required location.

Two other options that are available in the Scanner and Camera Wizard (once

images have been downloaded) are to order prints from an online service or to share them on the Web with an online image sharing service. XP offers default services for both of these functions, but there are also numerous other services on the Web that do the same things.

For a detailed look at online printing and online image sharing, see Chapter Eleven.

Select a location for the images and type a name for the new folder into which the images will be downloaded. Click on Next

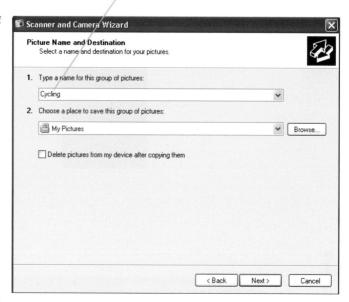

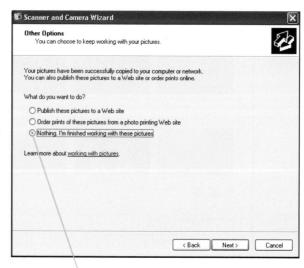

Click here if you do not want to do anything at present with the downloaded images. Click on Next

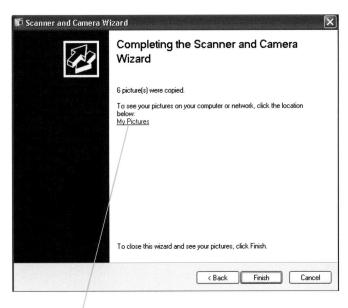

- Click here to view the downloaded images
 - The images can be viewed as a filmstrip

Images can be viewed in their respective folders at any time in XP by clicking on

the Start button and then selecting My Pictures. In most cases your picture folders will be contained within the My Pictures main folder.

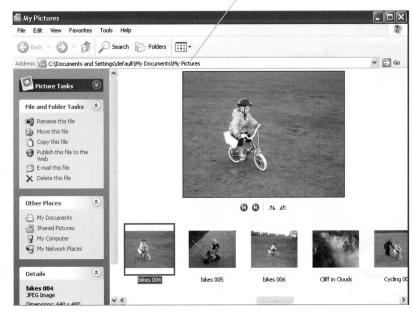

Adding digital devices

Windows XP allows you to add numerous digital devices, without having to load separately the software to operate them. To do this:

- Select Start>Control Panel from the Taskbar
- Click on Printers and Other Hardware

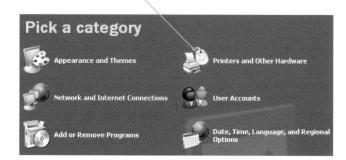

Windows XP has an enhanced Plug and Play facility, that allows you to install and use

new hardware, such as a digital camera or a scanner, without having to restart your system once the software for the device has been added.

Click on Scanners and Cameras

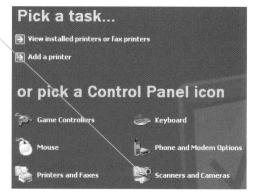

Windows XP contains drivers (the software that lets a digital device communicate

with the computer) for the most common digital devices. This means that it can install the software without the need for a disc. However, you may still need a disc if you want to use additional software that comes with the device or if you are using a less common device.

Click on Add an imaging device

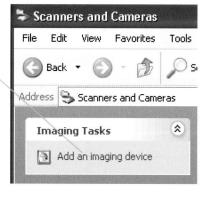

- Click on Next to move to the next page of the Installation Wizard
- Select the camera manufacturer and the model

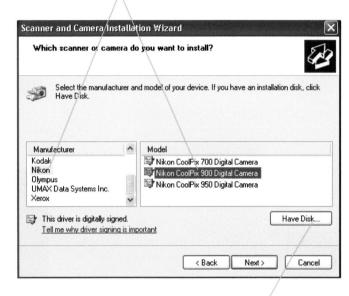

If XP does not provide a driver for your digital camera and you are having problems installing it from the

disc that came with the camera, try visiting the website of the camera manufacturer. All of the major companies have their own sites where you should be able to download the latest version of camera drivers. A lot of manufacturers also have information about their products' compatibility with Windows XP.

If you have the disc which came with the camera, click on the Have Disk button. Otherwise, click on Next

Automatic bort detection is the default setting when installing a new digital device. Select

port

Automatic

detection

and click

on Next

It can be left as it is unless you have a particular reason to change it.

Scanner and Camera Installation Wizard Connect your device to your computer. Plug your device into a port on your computer, and then select the port below. Available ports: Automatic port detection Communications Port (COM1) < Back Next > Cancel

You can give your digital device any name in Step 9. It does not have to match the actual

name of the device: it can be something like My Great Camera, if you want.

Enter a name for your digital device and click on Next

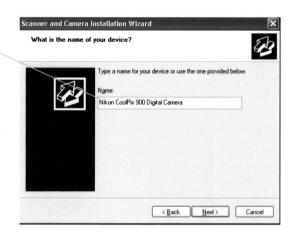

You can install as many digital devices as you like with the Scanner and

Camera Installation Wizard.

Click Finish. The files will be installed on your computer and the device will be displayed in the Scanners and Cameras window

The installed digital devices can be viewed by clicking on the Start button and

then on My Computer. Doubleclick on an icon to download images directly from it.

Viewing images

If you want to perform anything other than the most basic editing on images, then

vou should obtain an imageediting program in addition to using Windows XP.

One of the great benefits of XP is that you can view your images in a variety of ways without having to first open them in a separate image editing program. This can save a lot of time, since you can use XP to identify the images you want to use and then edit them in an image editing program. The initial view that you may come across when looking for images is the Tasks view (these are looked at in more detail on page 97). However, another useful option is to be able to view the folder structure of all of your own folders. This can give you quick access to a specific folder:

A list of the available folders is displayed here

Click here to move up to the root folder. All of the sub-folders are displayed, with their contents denoted as thumbnails (only if Thumbnail view is selected)

The folders can only be displayed as on the right if the thumbnail viewing option is

selected. See pages 92 and 94 for details on how to access and display this view.

If the folder structure is showing, click on the Folders button to return to the

Tasks interface.

Accessing viewing options

To access the various viewing options within XP:

For a detailed look at the functions of XP. have a look at "Windows XP in

easy steps" in the Computer Step range.

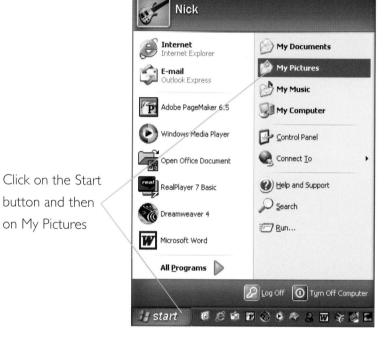

Individual folders can be customized by opening them and selecting

View>Customize This Folder from the menu bar. This provides details about the selected folder and also various choices for customizing it.

Select View from the menu bar to see the available viewing options

Filmstrip

This displays the images as a strip, in a similar way to film negatives.

Click on a thumbnail image to display an enlarged version

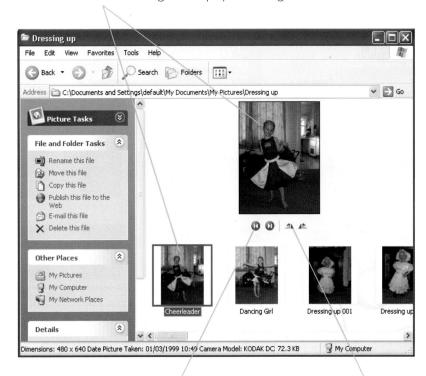

Double-click on one of the thumbnail images to view it at full size in

the Windows Picture and Fax Viewer.

> Click here to move backwards and forwards through the folders in My Pictures

Select an image and click here to change its orientation

Thumbnails

This displays all of the folders in My Pictures, or images within a folder, as thumbnails.

Thumbnails are a good way to view a lot of images auickly. However, it does not always

give a lot of detail about overall image quality, such as focus.

Different file formats are denoted by different icons in Tiles view, so that

you can quickly see the format of a particular image, or group of images.

Tiles

This displays images or folders as large icons, with the relevant file information next to them.

If there are nonimage files in a folder, these will be displayed with their own icons in

Tiles, Icons, List and Details views.

Icons

This displays images or folders as small icons, with only the filename below them.

List

This displays images or folders as a list. with the filename next to them.

The items shown in Details view can be customized by selecting

View>Choose Details... from the menu bar and then checking on the details you want displayed.

Details

This displays images or folders as a list, with file information next to them.

Windows Picture and Fax Viewer

This displays images at full screen size:

As the name suggests, the Picture and Fax Viewer can also be used to view

faxes that have been sent to your combuter.

The Picture and Fax Viewer is a useful feature for checking color balance and

focus in an image.

From any other screen view, doubleclick on an image

The image is displayed at full size

There are controls at the bottom of the Picture and Fax Viewer that allow you to move

through the images in the current folder, zoom in, change the orientation, save them to disc, send images directly to a printer or delete them.

Editing and printing

There are a number of basic editing, sharing and printing tasks that can be performed within the Windows XP environment. These are available when folders are being viewed, unless Folders view has been selected.

The Publish this file to the Web option provides a Wizard that connects to

various services that offer online sharing of images. This is covered in Chapter Eleven.

Organizing files

Select an image and click on one of the options in the File and Folder Tasks folder

Downloading images

The Order prints online option provides a Wizard that connects to various services

that offer online printing of images. This is also covered in Chapter Eleven.

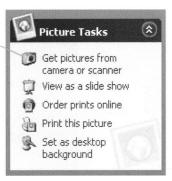

The Files and Folder Tasks. Picture Tasks and Details panels are available

regardless of which view option has been selected. The only time they disappear is if the Folders button has been selected on the toolbar.

Details

In any view, see an image's details here

Create a slideshow

Open a folder and click on View as a slide show

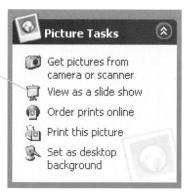

If the Control bar is not showing, drag the cursor across the slideshow screen. All of the files in the folder are displayed sequentially. The slideshow can be manipulated using these controls, which enable you to start, pause, move to the next/previous image or stop the slideshow

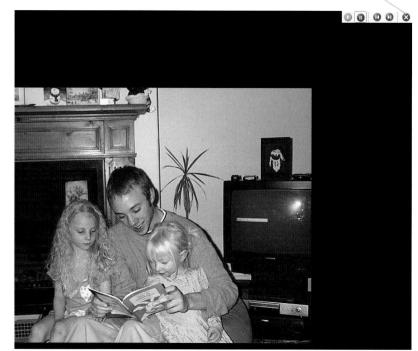

Click once on the slideshow screen to move immediately to the next image.

Most images benefit from some image editing before they are printed.

However, it is still possible to print them out directly after they have been downloaded from the camera.

For the best quality prints, use the printer's highest print resolution (e.g.

2800 x 1400 dpi) and photo quality paper.

Printing

Windows XP provides a Printing Wizard that can be used to print images, rather than having to first open them in a separate image editing program. Images can be printed either individually or as a batch and this can be determined once the Wizard has been started. To print images:

- Open a folder and click on Print this picture, in Picture Tasks
- Picture Tasks Get pictures from camera or scanner 🕽 View as a slide show Order prints online Ballet 001 Print this picture Set as desktop background
- Click on Next on the first page of the Wizard
- Check on these boxes to select individual images

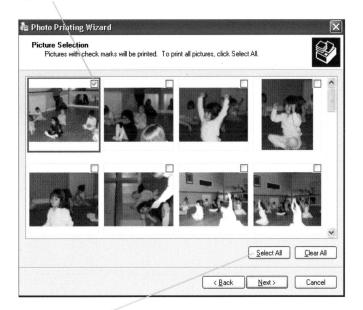

Click here to select all the images in the folder for printing. Click on Next

Always check your printer settings before you finalize the printing command.

Make sure that items such as the paper type, orientation and output resolution are all as you want them.

Select the required printer and click here to select any print preferences. Click on Next

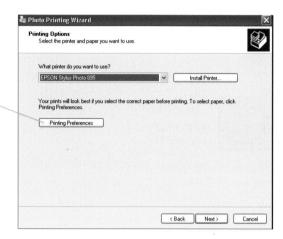

Select the layout for the way you want the selected images to be printed. Click on Next

The layout options offer a variety of ways that the selected images can be

printed on a page. These include full size, a contact sheet or wallet sized prints.

Allow color prints to dry for a minute or two once they have been printed. In

some cases the ink may smudge if they are handled too soon after they have come out of the printer.

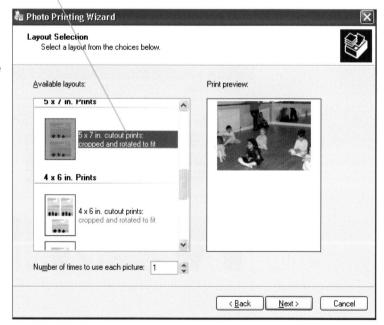

The Wizard informs you once the images have been printed. Click on Finish

Using Mac OS X

OS X is the latest operating system by Apple Computers, designed for their Macintosh range of desktop computers and laptops. All new Macs use OS X and it offers an unrivalled combination of stability and ease of use. This chapter looks at how OS X can be used in relation to digital images and it concentrates on one of its applications, iPhoto.

Covers

Downloading images 102			
Obtaining iPhoto 103			
Using iPhoto 104			
Importing with iPhoto 105			
Organizing with iPhoto 106			
Editing with iPhoto 109			
Services with iPhoto 110			

Chapter Six

Downloading images

For a detailed look at OS X. have a look at "Mac OS X Panther in easy

steps" in the Computer Step range.

If your digital camera is not automatically detected by OS X and the Image

Capture Application you will have to install the camera software, which should be supplied on the disc that came with the camera.

The Mac OS X (pronounced "ten") operating system is a further step by Apple Computers to create what they call a "digital hub" for computer users. Their intention is to create a computing environment that is easy to use, stable and allows users to harness the power of the digital world to its full potential. This includes music, video and of course digital photography. OS X provides programs for all of these areas and it aims to make downloading and using digital images as easy as possible. There is a specific program for doing this, which is discussed in the rest of this chapter, but images can also be downloaded directly by OS X:

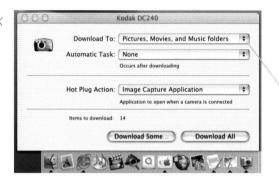

As soon as a camera is attached it is recognized by OS X. Click here to select a location for downloaded images

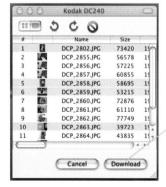

Select specific images to be downloaded and then click on Download

Rename images as soon as they are downloaded. This will make it easier to find

individual images.

The images are downloaded into the folder selected in Step 1

Obtaining iPhoto

iPhoto is the image management program from Apple, that runs exclusively on the OS X system. It can be bought and downloaded from the Apple website. The intention of iPhoto is to make the organizing, manipulation and sharing of digital images as easy as possible. It is perfectly possible to use digital images on a Mac without iPhoto, but if you are using OS X then the digital experience will be greatly enhanced by this easy to use but highly effective program. To obtain iPhoto:

Click on the Software tab on the Apple website navigation bar

Click on the iPhoto download link

The iPhoto download file is approximately 32Mb in size.

downloaded, an icon will appear on the desktop. Double-click on this and then double-click on the installer icon to complete the installation of iPhoto.

Read the requirements and click the **Buy Now** button

Using iPhoto

When iPhoto is first opened a dialog box appears asking if you want to launch iPhoto automatically whenever a digital camera is connected. This is probably the best way to download images with OS X. Click on Yes to activate this

If you select No in the Launch Automatically dialog box, then the system Image

Capture Application (see page 102), will be used to download digital images from your camera.

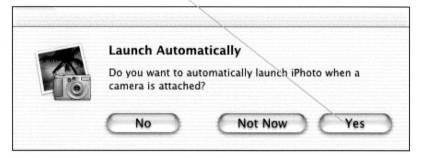

The Photo Library, where downloaded images will be displayed

Click on the Last Import option to see the most recently downloaded

images.

The Photo Library is where all downloaded images are displayed. If new

albums are created and images placed into them, the images are visible in the album but these are, in effect, just a reference back to the image in the Photo Library.

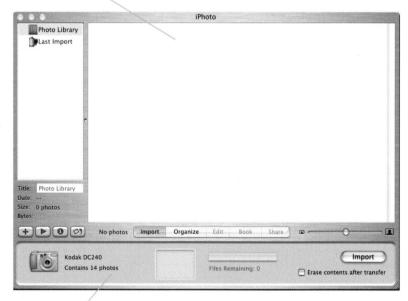

The connected camera and the number of images on it are displayed here

Importing with iPhoto

iPhoto downloads all of the images held on a camera's memory card; there is no

facility to select specific images before downloading.

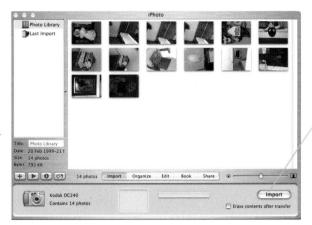

Click here to import images into the Photo Library

Check on the "Erase contents after transfer" check box if you want images to

be removed from your camera's memory card once they have been downloaded by iPhoto. If this is left unchecked then all of the images will be downloaded again the next time you connect to iPhoto.

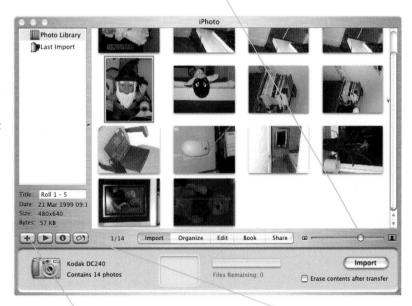

- Click here to create a new album. Enter its name and click on OK
- Select an image and click here to change its orientation

Drag this slider to change the size at which

the thumbnail images are displayed

Organizing with iPhoto

Images in the Photo Library can be named and placed into new folders, such as the one created on the previous page:

When images are first downloaded they are given a sequential roll number and also

a number within the roll. This is similar to the negative strip that is included with hard copy prints.

Select an image and click here to enter a new name for it. Check on the Titles box to see the name

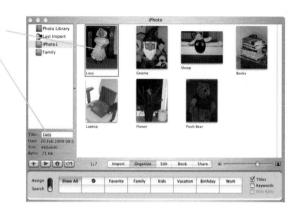

Multiple images can be selected by dragging around them or selecting them

while the Apple button is held down on the keyboard.

If you delete an image from the Photo Library it will also be deleted from any

other albums in which it appears. This is because each image in an album is only a reference back to the master image stored in the Photo Library.

Select all of the images to be placed in the new album

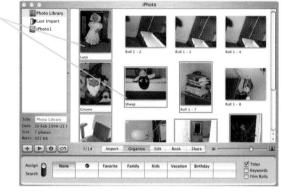

Drag the images into the new album. They then appear on their own, without the other images from the camera

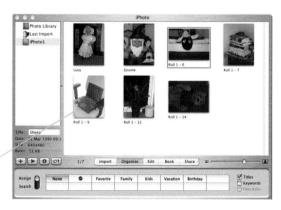

View keywords for all of the current images on view by checking on the Keywords

check box. Check it off to hide all keywords. However, if the keyword tick has been added (see below), this will still be visible.

Assigning keywords

Click on an image and check on the Keywords check box

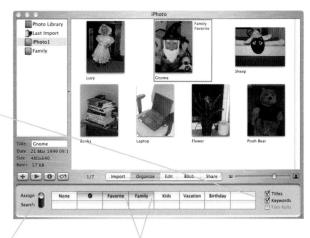

Drag this slider to Assign and click here to add keywords to the image

WARE

Be consistent in your use of keywords and try and use the same system for all

images that you download. Otherwise you may find that searching becomes erratic once you have thousands of images to look through.

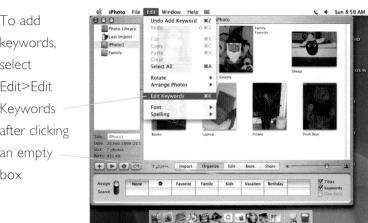

Searching for keywords

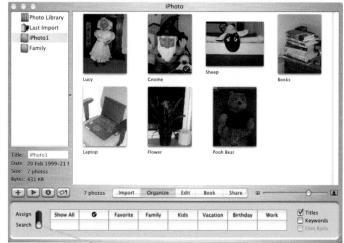

Several keywords can be used in a search. This narrows down the results but it can

miss some items if they have not been assigned all of the keywords in the first place.

Drag this slider to Search

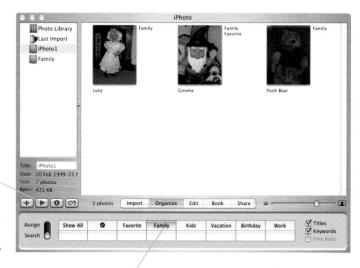

- At any point while working in iPhoto, click on this button to view the images

in the current folder as a slideshow. This comes complete with a musical accompaniment, which can be changed using the iPhoto preferences. These can be accessed by selecting iPhoto>Preferences from the menu bar.

- Click on a keyword that you want to search for
- All of the images that have been assigned the selected keyword will be displayed

Editing with iPhoto

When using the Crop tool, the area within the selection is the part of the image

that will be retained.

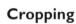

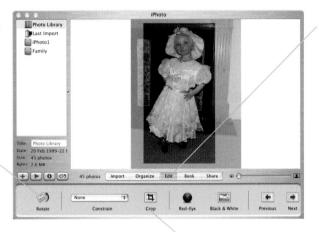

some basic editing functions can be performed:

First, click here to access the editing options. Each image is displayed individually

Click here to change the orientation of the currently selected image.

> Now click on the Crop button and drag across the image to select the area to be kept. Click on the Crop button again to remove the grayed-out area

> Although iPhoto is not a fully-featured image editing program,

Removing red-eye

Use the Previous and Next buttons to move through the images in the current folder.

The Red-Eve function changes the color of any red area that has been selected. To

get the most accurate results, zoom in on the image as much as possible and then select the affected area.

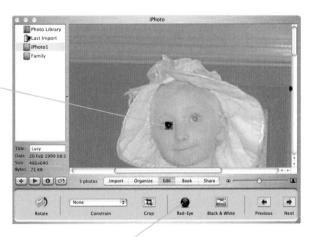

Click on the Red-Eye button again to repair the red-eye

Services with iPhoto

A warning triangle is displayed next to any images that iPhoto judges are not of sufficient

resolution to be printed at maximum quality.

Creating a book

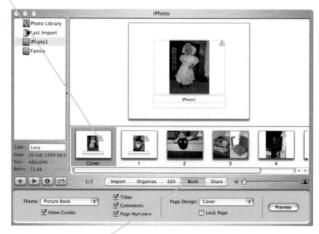

Click here to access options for ordering a bound book created from your images

Sharing images

There are a number of options within iPhoto for sharing images:

HomePage is part of .Mac on the Apple website. This is a subscription

service that can be used to share images online. HomePage is for creating your own Web pages, which are then hosted on Apple's own servers. To register for .Mac, go to the Apple website at: www.mac.com

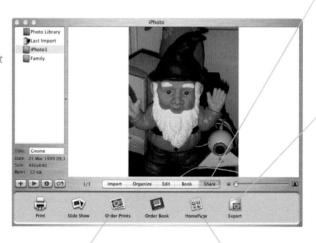

Click here to export images into a different format

Click here to order online prints

Click here to display images on the Apple HomePage site

Image editing software

This chapter gives an introduction to the different types of image editing software on the market. It shows how the software operates and illustrates some of the effects that can be achieved.

Covers

Entry-level programs 112
Professional programs 114
Opening images 116
Viewing images 118
File formats 120
Saving files 123
Touch-up techniques 124
Special effects 125
Types of projects 126

Chapter Seven

Entry-level programs

User interface

When you start working with an image editing package, set up a directory, and

sub-directories if necessary, for your images. This way you will always know where to go to find your images and you will not have to jump between different directories.

As the popularity of creating digital images via digital cameras and scanners increases, so too does the amount of image editing software. The majority of this is aimed at the general consumer market. For approximately \$50 (£40) or under you should be able to buy a very solid editing package that will allow you to undertake a variety of editing functions and also apply some interesting special effects and touch-up techniques.

Entry-level editing packages are user friendly and the interface consists of easy-to-follow icons, toolbars and Help text boxes. Most also have their own library of images which are useful for experimentation before you start creating your own. One of the best ways to get used to an image editing package is to use a copy of an image and experiment with as many of the different menu options and icons as possible. Even if the image ends up as a mess it will not matter if it is a copy.

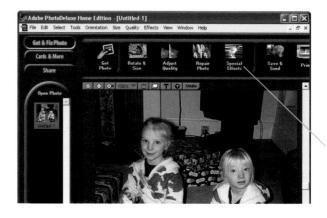

Entry-level editing packages have easy to follow graphical icons and toolbars

All editing programs work best with the monitor set for the maximum

number of colors that it can view (usually 16 million). Some programs will not function unless this setting is applied.

The main functions available in the editing programs are:

- Color editing
- Applying touch-up techniques
- Creating special projects, from greeting cards to wine labels
- Emailing, or faxing, images around the world. Most programs can do this by connecting directly with your email program or fax machine

It is possible to obtain demo or tryout versions of most image editing software.

This can either be done by downloading them from the company's website, or looking for them on the CD-ROMs that are attached to computer magazines.

The programs

There are dozens of entry-level editing programs on the market but five of the best are:

- Photoshop Elements. This is the latest program from Adobe and it offers extensive techniques for editing and enhancing images for both print and Web publication. It crosses the divide between entry level programs and professional ones since it has the power of a lot of professional programs without the steep learning curve that some of them require. For more information, see the Adobe website at www.adobe.com
- Adobe PhotoDeluxe. Generally now surpassed by Photoshop Elements, this is nevertheless an excellent product in terms of functions and ease of use
- Ulead Photo Express. Similar to PhotoDeluxe, with easy to use icons and a good range of functions but more limited project options. For more information, see the Ulead website at www.ulead.com

Some people use two or three different image editing packages, as they prefer

particular programs for certain functions. This is a good idea and allows for more flexibility with your image editing.

- Roxio PhotoSuite. Another program in the PhotoDeluxe/ PhotoExpress mode but with perhaps not such a wide range of functions. However, functionality can be in the eye of the user. For more information, see the Roxio site at www.roxio.com
- Microsoft Picture It. This is a very easy-to-use program from Microsoft that offers a range of some of the most commonly used image editing techniques. For more information, see the Microsoft site at www.microsoft.com

Professional programs

Price and power

If you are prepared to pay several hundred dollars (or pounds) for an image editing program then you will get a product that should fulfil all of your imaging needs and more besides.

The professional models are designed specifically for designers. graphic artists and desktop publishing specialists. They are unsurpassed in terms of color editing functions and if this is what you are interested in then one of these programs should be considered

The main drawback with these programs is that they can seem complicated and difficult to learn. Some prior knowledge of image editing is useful, otherwise it may take intensive use before you feel comfortable with the software.

User interface

Unlike the general level programs, the professional versions offer very little in the way of guidance for the users. The functions are contained within various toolboxes and menu bars and it is a case of trying each one to see what it does. When you are doing this, use a test image so that if you do something you are unable to correct you will not have wasted a valuable image of your own.

Professional packages have numerous menus and toolbars:

If you want to learn about a professional image editing program, make

sure you have the time and opportunity to do so properly. It is not something that can be fitted around your normal daily tasks.

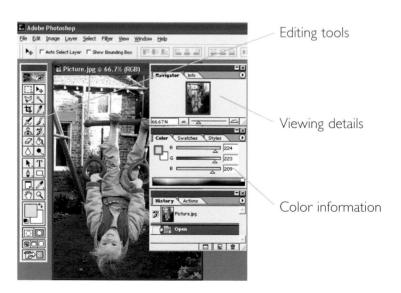

The main drawback of Photoshop is the brice, which is aimed at the

professional market. A more realistic option may be Photoshop Elements, the consumer version of the full Photoshop.

If you want to unravel the mysteries of Photoshop or Paint Shop Pro

then an excellent place to start is Computer Step's own titles:

- "Photoshop CS in easy steps"
- "Paint Shop Pro 8 in easy steps"

The programs

- Adobe Photoshop. This is the top-selling image editing program and for power and versatility is it hard to beat. It can edit colors with great precision and has over 80 filters for adding special effects such as blurring and watercolor techniques. An excellent program for business users, or those who are into digital imaging in a big way. For more information, see the Adobe website at www.adobe.com
- Paint Shop Pro. For value for money this is one of the best programs on the market. The interface is similar to that of Photoshop but there is not the same range of sophistication. Nevertheless, it is an excellent product, which goes some way to bridging the gap between entry-level and professional programs. For more information, see the website at www.jasc.com

Paint Shop Pro is reasonably priced and an excellent all round editing program:

Ulead PhotoImpact. PhotoImpact is similar in terms of power and functionality to Paint Shop Pro. As with Paint Shop Pro, it does not have all of the power of Photoshop. For more information about PhotoImpact, look at the Ulead website at www.ulead.com

Opening images

Image editing software is the magic dust that transforms images by changing their basic elements (such as color definition, brightness, contrast and saturation); enables editing techniques which can alter or remove objects in the image; and adds additional elements to the image.

If you have never seen an image editing package before then the collection of buttons and icons can be a bit overwhelming at first. But, thankfully, most of the programs work on the same principles - you obtain an image from a selection of possible sources, you make your editing changes and then you print the image, email it or publish it on the Web.

Obtaining images

When you first open an editing program you will want to open an image so that you can work on it. On the higher level programs you will just have the standard File>Open option. But with the entry-level programs you may encounter a screen that is similar to this, containing options for starting the image editing process (this is Adobe Photoshop Elements):

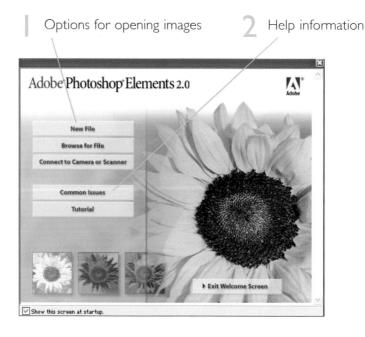

Opening images from the computer

When you elect to open an image from the computer the options that you are given include:

- Open an image from an image library that has already been created
- Open an image that is pre-installed with the software
- Open a Clip Art file. It is impossible to escape from the ubiquitous Clip Art. This can be useful if you want to create a humorous montage using a photographic image and Clip Art
- Open a file from your own hard drive on the computer. To do this you will have to have already created and saved some images

digital device and it does not appear

If you are trying to acquire an

image from a

- on a pick list then this is probably caused by one of two things:
- · Firstly, the device is not connected properly or turned on
- · Secondly, the system software connecting the device and the computer has not been installed correctly

Opening images from a digital device

Both Windows XP and Mac OS X have the means to recognize digital devices as soon as they are connected to a computer. The images can then be downloaded directly into a folder within the computer. If the operating system does not recognize the type of camera that has been connected, then you will be given the option of loading the camera software (i.e. the drivers that enable the camera and the computer to communicate with each other) from the disc that came with the camera. If this is not possible, visit the website of the camera manufacturer and download the relevant drivers from there.

Most image editing programs also allow you to download images directly into them from the camera or another imaging device. This is usually in the form of a downloading wizard or an Import option:

Viewing images

A view of 100% or I:I may not occupy the whole screen in some editing

packages. This will depend on the size of the actual image rather than the viewing ratio. If you want to view an image on the entire screen then select the Fit to Window command, if there is one.

Once you have your image on-screen, and you have congratulated yourself on getting all of the connections and settings correct, you can then decide how you want to view it. This will depend largely on what you want to do with it:

- For overall color editing, a Fit in Window setting is best. This means that all of the image can be seen on screen
- For editing that involves removing unwanted items, such as people or objects, a zoomed-in ratio of 2:1 or 3:1 is sufficient
- For very close-up work requiring individual pixels to be edited, a magnification of 10:1 or above may be required

Each program deals with magnification in a slightly different way, so experiment to see which setting suits your needs best.

An image at 50% magnification

If an image is viewed at a very high magnification it becomes bixelated. This

means you can edit individual pixels, which can be useful for techniques such as reducing red-eye.

The same image at 400% magnification

Magnification options

Each program has its own way of providing magnification controls. Some examples are:

PhotoDeluxe has magnifying glass controls:

This increases magnification for the whole image

This decreases the magnification for the whole image

This increases magnification, centered on the point where the icon is placed

Photoshop has percentage settings and also specific viewing settings:

Paint Shop Pro shows the image magnification in cumulative factors:

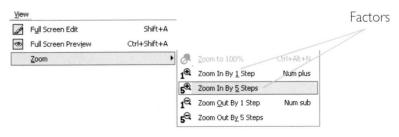

If you are using a magnifying glass icon to enlarge one particular area in an image

you will have to reposition it for each level of magnification. This is because the point that you want to see will move its coordinates in the image each time.

When performing very precise image editing tasks, such as cloning small

areas, or reducing red-eye, you may want to zoom in on an image using the maximum level of magnification available in your image editing program.

File formats

GIF comes in two varieties, 87a and 89a. These are more commonly known as

nontransparent GIFs and transparent GIFs respectively. With a transparent GIF the background can be made seethrough. This is very useful for Web images: if you want the subject of an image to appear against the Web page background, you can do this with a transparent GIF.

RAW files can be edited with a program such as Adobe Photoshop. Since the data

has not been processed in any way, RAW files can have some very sophisticated color corrections applied to them. Think of them as a digital negative of an image. They can then be saved in a standard file format.

There are two methods for compressing digital images; lossy and lossless.

Lossy means that some image quality is sacrificed, while the lossless method only discards image information that is not needed.

Digital images can be created and saved in a variety of different formats. This is not always immediately apparent when you view the images on screen, but the file format can have important implications as far as the use of the image is concerned.

The two main areas that designers of image file formats consider are:

- The size of files how to get good quality images that do not take up a lot of disc space
- The quality of images how to produce images that give the best printed quality possible

Because of this, different file formats are better suited for some purposes than others.

RAW files

RAW is the description of image data that has not been converted into a specific file format. No in-camera processing is performed and RAW files are generally smaller in size than when an image is saved in a specific format. RAW format is mainly available with higher-end cameras.

GIF files

GIF (Graphical Interchange Format) is one of the two main file formats that is used for images on the Web (the other being IPEG). It was designed with this specifically in mind and its main advantage is that it creates image files that are relatively small. It achieves this principally by compressing the image by removing unnecessary or irrelevant data in the file.

The main drawback with GIF files for digital images is that they can only display a maximum of 256 colors. This is considerably less than the 16 million colors that can be used in a full color image. Therefore photographs in a GIF format may lose some color definition and subtlety of tone.

Despite its narrow color range GIF is still a very useful and popular format. It is excellent for displaying graphics and even photographs can be of a perfectly acceptable standard for display on the Web.

IPEG images only achieve their full effect on the Web if the user's monitor is set to

16 million colors (also known as 24 bit). Most modern monitors are capable of doing this but, in some cases, the user may have set the monitor to a lower specification.

IPEGs tend to deteriorate the more that they are worked on and every time

they are saved. This is because they are compressed during each save operation. If you are going to be doing a lot of image editing on an image, create it as a TIFF to do the editing and then save the final version as a IPEG.

You should note the following file extensions (the last is the least common):

- · GIF files .GIF
- · JPEG files .JPEG
- · PNG files .PNG

IPEG files

IPEG (Joint Photographic Expert Group) is the other main file format for Web images and it is the one that, as the name suggests, specializes in photographic images. A lot of digital cameras automatically save images as IPEGs.

As with GIF, IPEG compresses the image so that the file size is smaller; it is therefore quicker to download on the Web. One downside to this is that the file is compressed each time it is opened and saved, so the image quality deteriorates correspondingly. When a file is opened it is automatically decompressed but if this is done numerous times then it can result in an inferior image.

The main advantage of JPEG files is that they can display over 16 million colors. This makes them ideal for displaying photographic images. The color quality of the image is retained and the file size is still suitably small.

PNG files

The PNG (Portable Network Group) file format is a relatively new one in the Web image display market but it has the potential to become at least as popular as GIF and JPEG. It uses 16 million colors and lossless compression, as opposed to JPEG which uses lossy compression. The result is better image quality but a slightly larger file size. Since PNG is a developing format there are a few factors to bear in mind when using it:

- Not all browsers support the PNG format. This will undoubtedly change as its use becomes more widespread but it is a consideration at the moment
- PCs and Macs use different PNG file types and, although both types can be opened and viewed on both platforms, they appear to their best effect on the platforms on which they were created
- PNG files can contain meta-tags indexing information that can be read by Web search engines when someone is looking for your website

Kodak have developed a file format that is specifically for use with images on

CDs. It is called Photo CD and can store images on a CD at five different sizes. Most image editing programs can open Photo CD files but they cannot save to this format.

For your interest, you should take note of the following file extensions:

- TIFF files .TIF
- BMP files .BMP
- EPS files .EPS
- FlashPix files .FPX

There are other file formats for images but the ones discussed here are the

most common.

TIFF files

The TIFF (Tagged Image File Format) format is one of the most popular and versatile currently in use. It creates files that have very good image quality and it uses a lossless compression system known as LZW (Lempel-Ziv-Welsh). This is the same system as used by GIF images and it can compress files by between 50–90%, while still retaining the image quality. However, with TIFFs this leads to file sizes that are generally larger than GIFs or IPEGs, so they are used for files that are going to be printed rather than displayed on the Web.

When a file is saved to the TIFF format a dialog box will appear that allows you to specify whether you want to apply LZW compression or not. Unless you have a good reason not to, you should select this option.

When saving a TIFF file you can specify the platform and whether you want to apply compression

Other file formats

Some other file formats you may come across when you are dealing with digital images are:

- BMP. This stands for BitMap Part and is a Windows format that has been popular in the past; however, it is generally now only used for specialist purposes
- FlashPix. This is a new file format that has been developed by a number of photographic and computer companies. The general aim of this format is to allow higher speed editing of large image files
- EPS. This stands for Encapsulated PostScript and is usually only used when files are being prepared for commercial printers

Saving files

File formats that are unique to a specific program are known as proprietary

formats. If you are working with these, then it is best to save a copy of the file into a more common format when you have finished editing. This way you can then open the file in another program if you want.

Most image editing packages have their own file formats (known as proprietary formats, see left) which they will automatically save files in, unless told otherwise. For instance, Photoshop and Photoshop Elements use proprietary formats with .PSD or .PDD extensions and Ulead has its own format with .TPX or .UPX. The main reason to use the program file format is that it will generally speed up the editing process and it will allow any elements that are specific to that program to be applied to the image. However, if you want to then open the image in another program or place it on the Web you should select Save As and chose one of the commonly used formats such as GIF, JPEG or TIFF.

Most image editing programs have a variety of options for saving images, including for use on the Web

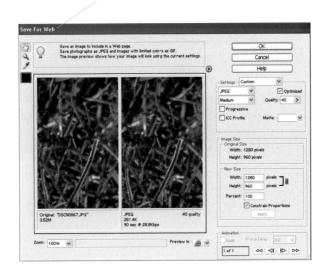

Some entry-level editing packages offer an icon-based interface for saving files. The professional packages will just have the standard Save and Save As commands and you then choose the file format and directory that you want.

It is possible to save the same image in numerous different formats. If you wanted to send a file to a printing bureau then you might save it as an EPS file, whereas if you were publishing something on the Web you could choose a JPEG format.

Touch-up techniques

Touch-up techniques go by a variety of names in entry-level programs but they all do the same general tasks – allowing the user to carry out operations like:

- Amending color appearance
- Amending image sharpness
- Changing image orientation
- Removing unwanted elements
- Converting the image into another format, such as black and white or watercolor

Some programs offer a variety of quick fix touch-up options within the same dialog box, like this one in Photoshop Elements:

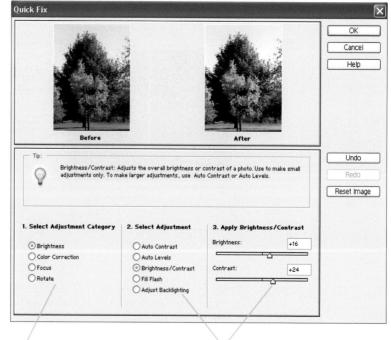

Always make a copy of an image before you start changing the size, color or

appearance. Therefore, if the editing does not turn out as expected you still have the original to fall back on.

Touch-up categories

Further options for each category

Special effects

As well as the standard editing techniques, image editing programs also offer a range of options that can best be described as special effects. Here is a selection:

If you intend printing your images once you have applied these types of

techniques, always run off a draft version first - the printed version may look different to the on-screen one.

- Distortion
- Textured
- Re-coloring
- Edge Effects
- Collages

Special effects are usually available in filter or effects palettes within image editing programs:

If you are interested in a particular technique, such as embossing, then

make sure the program has it before you buy. Most packages have a similar selection but there are some differences.

Effects palettes contain effects that can be added to images or text by double clicking on an effect

Filter palettes usually have additional dialog boxes to fine-tune the effects

Types of projects

Personal projects

One of the really fun aspects of image editing software is its ability to include images in a variety of fun, family-orientated projects. By following the on-screen instructions, your favorite images can be transferred to any of the following:

- Calendars
- Greetings cards
- Invitations
- Screen savers
- T-shirts
- Mugs

Always check to see which programs support the projects in which you are interested.

Most entry-level image editing programs have a range of special projects that can be completed using step-by-step instructions and pre-designed templates.

Programs such as Photoshop and Paint Shop Pro do not offer project options. So if you

are interested in these then stick to the entry-level programs.

Before you start including images in all manner of business bublications.

seek approval. Putting images into corporate documents is a business decision that could affect the public image of an organization.

In some cases the CD on which the software came will be required to access the templates.

Business projects

Most entry-level editing programs allow for images to be incorporated into specialist projects. From a business viewpoint this can be very useful. Everyday documentation can be given a stylish look with the introduction of a personal photograph or an image of the company's latest product. This can include items such as letterheaded paper, business cards, newsletter designs or logos for publications or Web pages.

Editing digital images

This chapter gives some editing tips and introduces some basic techniques for editing images, from color adjustment to creating the impression of speed.

Covers

The editing process 128
Before you start 129
Basic color adjustment 130
Improving brightness 131
Contrast and saturation 132
Correcting the balance 133
Adjusting colors with Levels 134
Selecting an area 135
Cropping an image 137
Reducing red-eye 138
Sharpening 139
Blurring and softening 140
Feathering 141
Cloning 142
Recognizing jaggies and noise 144

Chapter Eight

The editing process

The ability of editing software to enhance digital images should not be seen as

an excuse to take sub-standard pictures in the first place. Always try to take the best shot you can - a good original image will usually be preferable to a poor image that is then digitally enhanced.

Although digital image processing is not yet at the level of a James Bond film, where a blurry dot on the horizon can be transformed into a crystal-clear image of a secret rocket launch pad, it can nonetheless achieve some dramatic effects on even the most humble snapshot. In addition to improving and tweaking the color of images, editing packages can also change the appearance of items, get rid of the demonic-looking red-eye and even remove unwanted objects in a picture.

When you are editing digital images you should consider two main areas:

- The overall look of the image, which is controlled by various color enhancing options
- The editing and special effects that can be applied to the whole image or to selected parts of it

The overall look of an image is concerned with whether it is too dark, too light or if the colors look pale and washed-out. All of these areas can be improved with a few straightforward editing operations. For instance, if an image is too dark then it can be lightened with the Brightness command in image editing programs. This will lighten the image and a preview option will let you view the changes as they are made.

Think of a digital image as a collection of colored dots rather than one

complete picture. It is possible to edit each of the dots, either collectively or individually, or any variation in between.

Special effect techniques enable you to add a variety of effects to an image and remove blemishes such as red-eye or scratches. This can produce dramatic results but you should be aware of the following points:

- Do not expect your images to be transformed beyond all recognition — the software can only work with what it is given
- Do not worry if your first attempts are not perfect. Persevere and you will improve
- Be as creative as you like as long as you have saved a copy you can always go back to the start

Before you start

Even full-time snabbers take dozens of shots to get one usable image. Don't be

afraid to follow their example and then use the best ones for editing – after all, you aren't using up any film.

If you make a mistake when editing, most image editing software has an

Undo button. In some packages this only recovers the last action that you have performed while in others it allows you to retrace your steps for multiple edits.

Editing digital images can be an extremely fulfilling task. Mediocre photographs can be transformed into images that you would be proud to show your friends and family and even use in items such as Web pages or newsletters. However, before you start sampling the delights of digital image editing software there are a few basics that should be followed:

- Digital images can be opened just like any other file on your computer. In most programs it is a case of selecting File > Open and then selecting the relevant file. Alternatively you can open an image using the Open icon on the toolbar
- Before you start editing any digital image, make a copy of it first. This way, if it all goes horribly wrong, then you can still go back to the original and start again
- Have a good idea in your own mind how you want the finished product to look. This way you can build up the effect slowly rather than trying to do the whole process too quickly. Think of it a bit like creating a storyboard for making a film
 - Save your image frequently while you are editing it. Even though this should be done for all types of computer files it is particularly pertinent when you are editing digital images. The reason for this is that image files tend to be large and can cause computers to crash if they feel they are being asked to do too much processing. If this happens when you have undertaken a significant amount of editing then all of your work will have been lost since the last time you saved it. As a rule, save your image after every two or three edits. If this seems a little excessive, imagine how annoying it would be to have to go back to the beginning of your editing session and start again
- If you intend printing out your images then do this in draft at different stages of the editing process. Printed colors do not always look the same as on screen. If you check the printed colors as you go along then you will not be in for a nasty surprise at the end. Remember: images on photographic paper display color to a higher quality than normal paper

Basic color adjustment

Most people who take photographs like to see the fruits of their labors in glorious color. The ability to produce images with striking and vibrant colors is a valuable one, but even if you take pictures where the color is less than perfect, image editing software allows you the chance to redeem yourself.

Some editing programs have an Auto Levels command that adjusts all color

aspects of an image in a single function. Although this can be quick and effective it is generally better to adjust each color element independently.

All imaging software has the tools to increase or decrease the main areas of color, such as brightness, contrast and saturation. This generally changes all of the selected color levels for the entire image. While this can produce effective results, there may be occasions when you need to lighten one area more than another, or increase the contrast on only one part of the picture. This can be done by selecting the area that you want to edit and applying the relevant color controls to that section. So if you have a striking image and a nondescript, washed-out sky, you can select the sky area and enhance it using your color controls.

Fans of black and white images are also catered for in image editing software

and there are a number of techniques available.

Editing software can be used to make significant changes to parts of an image

Improving brightness

When you are increasing or decreasing the brightness, work with moderate

changes at a time. It is better to work gradually towards the effect you want so that you can view the variations in between. This not only lets you see how varying changes in brightness affect your image, it also enables you to become more familiar with how your editing software works.

The brightness of an image needs to be adjusted when the original picture is underexposed (dull all over) or overexposed (too much glare). This can be done by selecting the Brightness effect from your toolbox or menu bar and then applying it to the image. There will probably be a type of sliding scale, where you can define the amount you want the brightness increased or decreased.

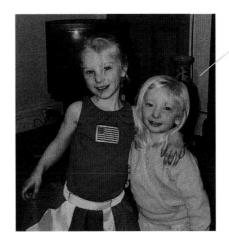

An image that is too dark would be of moderate value if it was from a film camera

Select the color controls to edit the image

Most editing software has a Preview function when you are editing an item.

This allows you to see the effect before you apply it to the image.

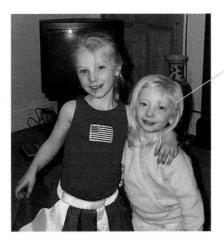

The final result is much more acceptable

Contrast and saturation

Contrast

The contrast in an image is the relationship between the dark and light areas in a photograph, or the tones. If the contrast is too great then the colors will look like they do not blend together properly, and if it is not enough they will not stand out sufficiently against each other. Contrast can be edited in the same way as brightness and in some programs it appears in the same dialog box. It can be beneficial to experiment with changing the brightness and the contrast together to see what effect this has on the image.

Hue can also be adjusted in the same dialog box as saturation. This alters the color of

individual pixels and can produce some interesting, surreal effects.

Saturation/Intensity

Saturation increases or decreases the intensity of color in your image. In most editing packages this is done by dragging a sliding scale to add or remove color from your image. This can have a dramatic effect on images that appear slightly faded or washed-out. However, be careful not to overdo it or you may end up with images that look unnaturally bright.

The color saturation, hue and intensity in an image can be adjusted using sliding scales

If available, use Preview to make sure the color changes are producing the desired effect

Correcting the balance

The color balance is the relationship between the colors in your image. If the colors are well balanced then you should have a picture with a natural appearance, where no one color appears to dominate. However, it is a peculiarity of digital images that they sometimes suffer from an error in color balance. This could result in a beach scene having a blue tinge all over, indicating that the balance is incorrect and there is too much blue in the image.

There are two terms that apply to color balance: subtractive and additive.

Subtractive involves increasing the levels of colors other than the one you want to reduce (so if there is too much blue then you increase the levels of red and green). The additive method, however, involves adding the color at the opposite side of the color wheel to the one you want to reduce (so to reduce the blue again, you increase the amount of yellow).

(Of the two methods, the subtractive one usually works best.)

In most editing software programs, the color balance is altered either by:

adjusting a sliding scale

or

entering values into color levels option boxes

On the sliding scale you can adjust the levels of three combinations: Red/Cyan, Green/Magenta and Blue/Yellow. In each case the two colors are at the opposite sides of a standard color wheel.

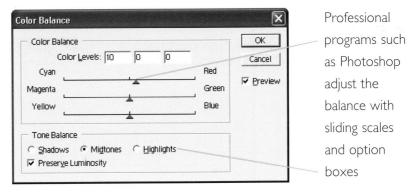

General level programs have a simpler set of sliding scales

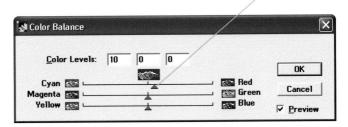

Adjusting colors with Levels

In more sophisticated editing programs, such as Adobe Photoshop, colors can be edited using a function called Levels. At first sight the Levels option is one that looks more like something from a scientific experiment than a device that is going to transform your humble images. However, if you persevere with it then the results are more satisfying than the all-in-one editors.

Do not expect to get the hang of the Levels command in a matter of

minutes. It is vital that you make a copy of an image before you start applying this technique because vou may well want to go back to the original.

The main difference between Levels editing and all-in-one editing is that Levels allows you to change the settings independently for different areas (highlights, shadows and midtones) of the picture. Values for each element can either be added into option boxes or they can be altered using a sliding scale. This is a fairly technical way of editing your images and one that needs a fair degree of practise.

> Levels controls can be altered by adding figures into the option boxes

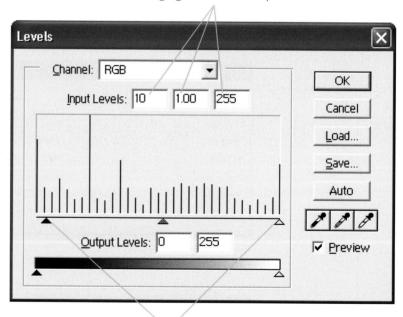

Tonal levels can also be adjusted by moving the sliding scales. This alters the color levels of the Shadows, Midtones and Highlights. Experiment to see how this affects different areas of your image

Selecting an area

For many editing functions it is necessary to select a specific part of an image. This allows for different techniques to be applied to separate areas of the picture. Therefore, tools to select parts of an image are a fundamental element of image editing software.

Rectangle tool

The standard tool for selecting an area of an image is a rectangle or, in some cases, an ellipse. To select an area, choose the relevant tool and click and drag over the required area.

The Rectangle tool can be used to select part of the image. This area can then be edited independently of the rest of the image

Freehand drawing tools are renowned for being notoriously jerky and difficult

to use accurately. Allow yourself plenty of practise before you embark on your "live" project.

Freehand tool

The freehand drawing tool goes by a variety of names (Lasso, Trace or Freehand) but it does the same job: it selects irregular objects. To do this, select the tool and then trace around the area that you want to select. Don't worry if you include too much in your selection; this can be edited using feathering or cloning.

Some programs have a magnetic freehand tool which can be used to select

areas by outlining them with consecutive straight lines. This can be a very accurate way to select irregular objects.

The Freehand tool can be used to draw an irregular outline around an object

Copying and pasting is very effective for creating symmetrical

patterns, where one item is repeated several times.

Once an area has been selected there are various options available:

- It can be edited independently of the rest of the image. This is particularly useful if you want to apply an editing technique (such as blurring) to one part of the image
- It can be Copied and then Pasted back into the same image. This gives a duplicate image that can be effective if you want to create an effect such as instant twins

Select an image and then Copy it

If you are pasting a subject from one image to another, make sure that the

background of the subject merges with the background of the new image. This can be done through the use of cloning - see Page 142.

Paste the image to create a duplicate. Take care when you are positioning the duplicate image

- It can be Copied and then Pasted into a different image. This is useful if you want to import a particular image into another application or if you want the image to appear against a new background
- It can be Cut from the image altogether. This can then involve cloning to fill in the resulting space
- It can be dragged to another part of the same image

Cropping an image

Cropping is a technique that is frequently deployed in the reproduction of photographs in newspapers and magazines. It involves removing an area of the picture that is considered distracting or unnecessary. Now, with the wonders of digital editing software, this invaluable service is available to all digital photographers.

Different editing packages handle cropping in differing ways but the general procedure is:

Select the Crop tool

Outline the area of the image that you want to keep

In most packages, if you crop an image and then decide you want some of the

background restored you can do this by expanding the image with the cropping tool - the cropped part has not been deleted, just hidden.

Select Edit>Crop or Image>Crop from the Menu bar or press Enter

The unwanted part of the image is then removed, leaving only the selected part

Reducing red-eye

Some digital cameras come with a reduce red-eye option. This usually works

with varying degrees of success and it is not something that could be called an exact science. Even the most basic editing programs offer a wide range of effects and touch-up techniques that can be applied to your images. In some cases this is done by dragging the relevant icon over the image and then applying the chosen technique. In more advanced programs, filters are used to select the relevant options. This is done by selecting the area that you want the technique to affect, then choosing the relevant filter. Some programs have up to 80 different filter options but it is unlikely that you would need this many.

Reducing red-eye

Anybody who has ever used a camera knows about red-eye, the condition where a perfect portrait is ruined because the subject comes out with menacing red eyes as a result of the flash reflecting in the pupils when the picture was taken. This still happens with digital cameras, but at least the software is now able to remedy it and give your subjects back their normal appearance.

The methods of reducing red-eye vary between programs but the fundamentals are similar:

- 1. Zoom in on the eyes
- 2. Select the affected area
- 3. Using one of the paint tools, recolor the eye area

Red-eye can also be removed by cloning the affected area (see page 142).

> Most image editing programs have an auto reduce redeye function

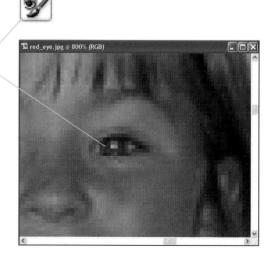

Sharpening

At first sight, sharpening appears to be the answer to every photographer's prayers: a tool that can improve and sharpen the focus of a blurred image. While sharpening can be a great asset to the digital snapper, it should not be seen as an excuse to try to take anything but perfectly focused pictures in the first place. However, sometimes blurred images do occur and sharpening is one way to try to improve them.

The technical side of sharpening involves the editing software adding extra definition along the borders between the dark and light areas of an image, or the areas with the highest contrast. This makes those borders stand out more. Once this effect is applied to the entire image it gives it the appearance of being in sharper focus.

A blurry image is unsatisfactory

Most software sharpening tools have the minimum options of Sharpen,

Sharpen More and Sharpen Edges, although the first one will usually give the most realistic effect. The more sophisticated programs allow for manual sharpening by specific amounts.

The image is still not perfect but at least it is more recognizable

Blurring and softening

Blurring and softening are essentially different degrees of the same effect. They can be used for two main purposes:

- Emphasizing a particular object in a picture by softening the background
- Creating the impression of speed by blurring the background behind a vehicle:

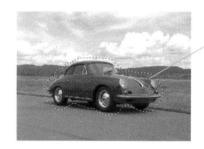

Select the image with the Freehand tool and then Copy the selected image

Softening is a more subtle effect than blurring and is best used for

backgrounds in portraits.

When selecting the amount to blur an image, do not get carried away or

else the background will lose all definition.

Entry-level image editing programs generally only have a single button or menu

option that applies a predefined amount of motion blur. More advanced programs usually provide a dialog box once the motion blur option is selected. This allows you to alter the amount of blur to be applied and also the direction in which it will appear.

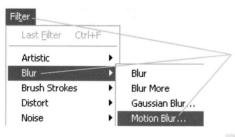

Select the Motion Blur filter option

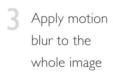

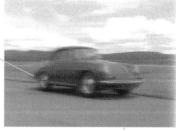

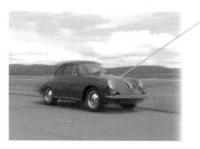

Paste the copied object back into the image and position it in exactly the same place. If necessary, apply feathering to the edges (see next page)

Feathering

This is a useful technique when you want to merge two images together. It is particularly effective when, on the facing page, one of the images is in sharp focus and the other is blurred. Feathering ensures that the join between the two is seamless.

Feathering is usually used when a part of the image has been cut or copied so that the rest can be edited (typically when you want to create a blurred background). The cut or copied area can then be pasted back into the image. At this point feathering can be applied so that the hard edges of the non-blurred image merge into the blurred background. See the following:

When you are applying values for blurring and feathering within the same image,

use the same amounts for both techniques. This way the blurred and feathered sections will match exactly.

feathered edge that will blend into a blurred background

Cloning

It is best to start off by removing small objects and then cloning the resulting holes. As

you perfect your technique you will be able to move on to larger objects, like removing people and buildings. With larger objects you have to be careful to clone from several different points or else vour seamless background will start to look like a symmetrical grid.

One of the main items on a digital photographer's "wish list" is the ability to remove unwanted items and then fill-in the resulting space with the same background as the rest of the picture. What was once thought of as the realms of science fiction is now perfectly possible with editing software and is known as cloning.

The cloning tool works by duplicating pixels next to the selected area. You select the pixels you want to use as your cloning pixels by clicking on them with the cloning tool. Then, with the mouse held down, you move the cloning tool over the area that you want to change. The effect is similar to painting over a picture with a different color.

One of the main uses for cloning is for removing blemishes and unwanted marks. This is the type of technique that magazines use frequently to make their models look as perfect as possible (which gives a modicum of reassurance to the rest of us). In this instance a mole or wrinkle is covered up by cloning the area of clear skin next to it.

If an image has minor blemishes (such as spots), these can be removed by cloning the area next to them

Cloning can also be used to remove irritating features such as red-eye, scratches on the

image and specks that may appear on your picture. Always zoom in on the affected area.

Cloning tools can be selected in a variety of sizes (thin to thick) and at times it is a bit like an artist trying to fill in a gap in a painting.

Large objects can also be removed in a similar way to copying them with cloning. To

do this, select the background as the starting point and then drag the cursor over the area to be removed. The cloning tool may have to be reset so that different parts of the background are used to create a seamless effect.

When you are removing objects with cloning, make sure that you also remove

any shadow that they create in the image. Otherwise, you may end up with a case of a shadow being cast by an invisible object.

In some programs the cloning tool is known as the Rubber Stamp tool, but it

performs the same function.

Cloning can also be used to copy or remove larger objects from an image such as people or buildings:

- Open an image containing elements that you want to clone
- Select the cloning tool

- Select an area that you want to use as the cloning area
- Drag the cloning tool where the cloned image is to appear

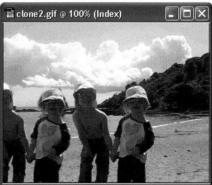

Once the cloning is completed the rest of the image can be edited if required

Recognizing Jaggies and noise

Jaggies and noise are two technical terms that have emerged from the digital imaging industry (every industry has to have its own jargon, it seems).

Jaggies refers to the loss of definition in an image that has been compressed or enlarged too much, resulting in a jagged rather than a smooth image. This gives the image a grainy appearance that can have its uses for artistic effects but it is not very desirable if you want to have a smooth image. Jaggies are more likely to affect images with fewer pixels.

Noise can be caused by a lack of light on the subject when the picture was taken and gives a grainy result. Noise can be edited out using image editing software, but the end result is not always perfect. Alternatively, noise can be added to create an artistic effect:

Both jaggies and noise can be edited by applying a slight blur or softening to the

image. However, this can result in the main subject being out of focus. This can be improved by selecting the subject and then applying Sharpening to it.

Noise can also occur during the process of capturing an image on the

camera's image sensor and then transferring it to the camera's memory card. Generally, the better the camera, the less chance of high levels of noise occurring.

- Open an image to which you want to add noise
- Select Filter> Noise>Add Noise from the Menu bar
- With noise added, the image takes on a more artistic appearance

Further editing options

There is a wealth of options available within digital image editing programs. This chapter takes a look at some of them including: using layers, adding text and color, repairing damaged photographs and creating panoramic views.

Covers

```
Using layers | 146

Creating collages | 148

Panoramas | 150

Adding text | 152

Adding colors | 153

Special projects | 154

Effects and distortion | 156

Repairing old photographs | 158

Wallpaper | 160
```

Chapter Nine

Using layers

Layers, which are supported by some image editing programs but not all of them, are a function that allows the user to create multilayered images that are built up with different image elements and items such as text

Layers are a very useful way to add elements to an image without altering the original image – new elements are placed on top of the base image. An individual layer can be edited without affecting any other layers in the image.

Layers are controlled by the Layers Palette:

The text layer is always present, even if you do not add any text. In this instance the

layer is not visible. Also, it is not possible to delete or move the text layer.

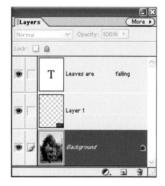

Some programs do not have a layers option. If you think you will be using this a lot

then look at one of the Adobe products, Paint Shop Pro or PhotoImbact.

An original image starts off with only a single layer. However, if text is added to the image this is automatically added as another layer. Once the text has been placed on the image it appears on the Layers Palette. This can then be edited at any time, if desired, by selecting that layer from the Palette.

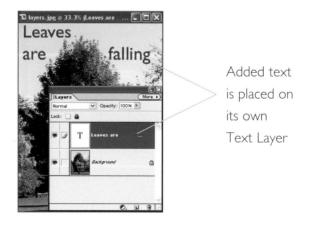

Up to 99 layers can be used in one image and these can be included:

- By dragging another image onto the active image
- By dragging a layer from another image
- By pasting an image that has been copied
- By using the Layers Palette

Lavers are a very useful device for creating collages because you can include numerous

items in the image and you can edit all of them independently of each other.

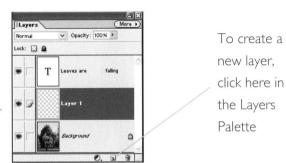

Each time you add a new element to an image, try to include it on a

different layer.

When a layer is added to an image it goes on top of the ones that are already there. However, it is possible to edit individual layers by selecting them in the Layers Palette. This does not change the order of the layers. You can also merge layers, but this should only be done once the entire editing process has been finished.

Layers are an excellent way to create complex images and can result in interesting effects

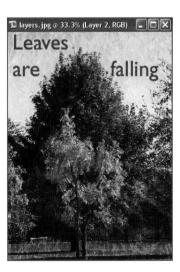

Creating collages

General level editing packages have step-by-step instructions for creating collages.

However, the programs at the higher end of the market do not offer so much guidance and it is up to users to find their own way.

Collaging is a technique that involves taking elements from two or more images and combining them into a new composition. This can be done to create a humorous effect by setting two incongruous items together or as a photomontage to accompany an article in a newspaper or magazine.

Collages can be fun, informative or outrageous

Collages rebresent a useful technique. Some uses include:

- · putting subjects against different backgrounds
- · swapping heads onto other bodies
- · adding extra elements to
- · combining two objects to give an unusual perspective

Although collages can be very effective, the following should be remembered:

- Use collages sparingly. If they are used frequently then their impact will be lessened and the effects will be wasted
- Plan you images beforehand (if possible) if you are going to be creating collages. For instance, if you want a collage of someone leaning against the top of a tall building, take one shot of the building and another of the individual leaning with their arm outstretched. This will make the editing a lot easier
- Make it obvious that the collage is not an original single image. Do not use them to mislead people
- Do not use collages to put people in embarrassing or compromising positions. This is particularly relevant if you are going to create a collage at work or place it in a publication that will be widely read

Once you have the images that you want to include in a collage you can create it with the following technique:

Try to use images that have a similar exposure to create collages. Otherwise you

may have to do some extra editing to one of the images. Open the images that you want to use to create the collage

When matching elements together, do so at a high level of magnification.

This way you can make the match as seamless as possible. Use the Freehand tool to select the first object. Delete the background

A Resize the objects and make any minor adjustments using the cloning or coloring tools

Panoramas

When capturing images to be used in a banoramic image. do so with the

same exposure for each one. This can be done by locking the exposure using the oncamera settings.

Any photographer who has ever stood in front of a majestic panorama of scenery is likely to have several photographs that have been taken in series to try to capture the full sweep of the view. Newer APS (Advanced Photo System) cameras have a setting that does this in one image, but digital photography goes one better by combining several pictures into one image:

Some standard image editing packages, such as Photoshop Elements, have the capability for creating panoramas (known as stitching) and there are also dedicated software packages for this purpose, such as Panoweaver (website at www.easypano.com) or Ulead Cool 360 (website at www.ulead.com).

When creating a panorama there are a few rules that should be followed:

- Make sure that there is a reasonable overlap between images. Some cameras enable you to align the correct overlap between the images
- Keep the same distance between yourself and the object you are capturing. Otherwise the end result will look out of perspective
- Keep an eye out for unwanted objects that appear in the panorama – if you are not careful they may appear in each frame

Some digital cameras have a panorama setting whereby you can create the

panorama within the camera rather than taking individual images and then stitching them together in the software.

Stitching functions in much the same way as manually creating panoramas: select your images, put them in order and then stitch them together. Practise may be required to get exactly the desired effect but the basic technique is:

If you do not have a tripod for panoramic shots then try steadying your arm against something like a tree or a rock.

Capture the images that you want to make into a panorama

Take at least two images for each part of a panoramic shot. This allows a bit

more versatility when matching images together.

Select the images from within the stitching software

Some photo stitching programs can create 3-D images which the user can then pan

around. This is generally done through the use of Javascript programming, but programs such as Panoweaver make this a relatively easy task to produce.

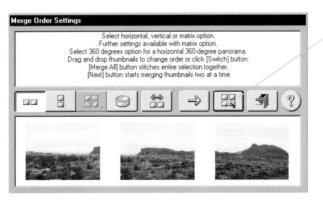

Select the Merge option

The images are now merged into one and can then be saved in the same way as any other image

Adding text

Do not add too much text to an image. It can make it abbear cluttered and

draw attention away from the image itself.

If you are adding text on a dark background then make it a light color; if it is on a

light background then make it dark. Some colors, such as yellow, do not always show up very well as text.

Adding text to digital images is a straightforward and effective way to personalize them and add individual messages. When you add text you begin by selecting the Text tool as you would in any word processing or desktop publishing program. The text formatting options can be selected before the text is added, or existing text can be formatted once it has been added to an image. Once it is on the image it can then be moved around and edited.

Adding text to an image

Open an image

Select the Text tool and select formatting options

Click on the image at the point where you want the text added and type on top of the image. The text box can then be moved around or edited

Adding colors

Additional colors can be painted onto an image in much the same way as adding text. This can be useful if you want to change a background element, such as the color of the sky, or alter the color of a piece of clothing.

To add additional color to an image:

Open an image

Use small brush sizes for adding precise details to colors and a larger one to

cover big areas.

When you are adding new colors to an image, try to make sure that they blend in well

with the ones that are already in the image.

Select the Paint Bucket tool or the Pen tool

Select the required color in the Color Picker and click OK

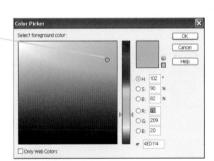

4 Color the object by clicking on an area with the Paint Bucket tool or by dragging with the Pen tool

Special projects

The use of printed images does not have to be confined to standard prints on letter-size paper. There are several other options that enable you to create a range of original and striking items or gifts.

When you are selecting an image to transfer onto a T-shirt, make sure that

there is a reasonable border around the main subject. This is because the software may trim the image if it is too big to fit properly onto the transfer.

Transferring images to T-shirts

Having a unique image on a T-shirt is a good way to stand out from the crowd and is surprisingly easy:

> Open the image that you want on a T-shirt

Print the image, in Mirror Image mode, on T-shirt transfer paper. The image will appear in reverse

Make sure you have the transfer sheet the right way up when you iron it onto the

T-shirt. Otherwise you will ruin your transfer, and possibly your iron too.

Iron the image onto a T-shirt

The image is now on the T-shirt

You can print cards on either normal or photographic quality paper.

However, if you use glossy photographic paper then the card will have a more professional appearance and it will be sturdier since this type of paper is thicker.

Cards, labels and calendars

Most entry-level editing programs offer a good range of cards, labels and calendars that can be used for presents or family gatherings.

The technique for creating these items is similar in most programs:

- Select Cards and the type of card you want to create
 - Select a layout

Some programs are rather slow at processing data for cards and they take up a lot of

memory in doing so. If possible, make sure that you do not have too many applications open while you are creating cards.

Select an image to fit on the card

Select a background template, such as Congratulations or Birthday Wishes

View the final version and edit if necessary

Effects and distortion

Also known as Filters in some programs, special effects and distortions can be used to alter images in a variety of ways. This can include changing the physical appearance of an image (such as adding a sphere distortion effect) or adding color effects (such as a colored pencil effect).

The basic editing function of effects and distortion is straightforward: you open an image and then you select an effect that is automatically applied to the image, or a selection within it. Other effects have dialog boxes into which values can be added to adjust the level of the effect. This is useful as it offers a greater degree of sophistication when applying the effect. To do this (in Photoshop Elements):

Try not to overdo the amount of distortion that you apply to images. This may produce

what is a striking image to you, but someone who is not so familiar with it may not be at all sure what the image is.

Open an image and double click on a Filter effect in the Filters Palette

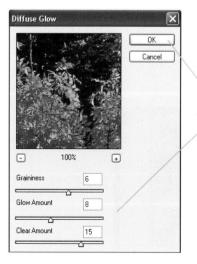

Make the required selections in the dialog box and click OK. The effect will be applied to the image, or selection

Uses for special effects

Although it can be great fun to add distortion effects to images of friends and family and colleagues at work, there may come a point when you want to do something a bit more constructive with the special effects in your editing software.

With a little planning and organization it is possible to apply special effects that create an imaginative and eye-catching image, rather than just a humorous one. The key to success is to experiment with the special effects first and then think of images to capture that will best complement these effects.

Some suggested uses are:

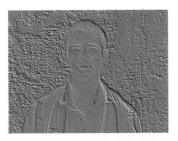

Use embossing to create metallic looking 3-D images. These can be particularly effective on Web pages

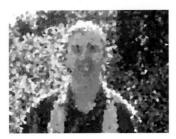

Use an impressionist effect for your own works of art

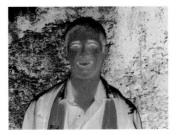

Use a negative effect to create an image for a photographic topic

Repairing old photographs

Image editing software is an excellent option for restoring the quality of old photographs or ones that have been torn or crumpled. In order to do this you have to get them in a digital format for the editing process. This can be done by:

- Scanning the photograph. This is the best option and if you do not have a scanner yourself then it could be done by a color-copy print shop. Try to get the original image scanned as large as possible as this will make it easier to work with
- Capturing an image of it with a digital camera. This works best if you have a macro close-up facility

If you want to restore an old photograph it can be made to look even more

realistic by adding a sepia tint to the image. If the editing package has this facility it is usually found in the touch-up toolbox or menu.

Image editing software can make dramatic improvements to images that are faded, torn or scratched. This is particularly useful for old black and white photographs

Before you start removing tears and lines from the image there are a number of steps that you can take to improve the final image:

- Adjusting the color and contrast. If the color quality of the image is not very good to begin with then it will not improve once you have given it a smoother look. Test different color settings to see which ones look the best
- Applying a neutral background. This can be particularly effective if the picture is a portrait that has been taken against a plain background. If this is full of blemishes then it would be a lengthy task to correct all of them. A better idea is to select the subject, copy it, then paste it into another file

Once you have a digital image of the old or damaged photograph it can then be edited using the following procedure:

If you want to repair a damaged print properly, it is essential that you take your time. In

all probability you will have to clone numerous different areas to cover all of the blemishes and this is a task that will have to be performed dozens of times in order to cover all of the different colors of the image.

It will probably also be necessary to work with the Cloning tool set to a small size so that you can zoom in and work in close-up detail.

Adjust the color and contrast

Zoom in on the affected area

Select the Cloning tool and the area to be cloned. Repeat this with all of the affected area

Wallpaper

Most entry level programs have an option for setting a particular image as desktop wallpaper (or a screen saver):

Open an image and select the required option from the menu bar

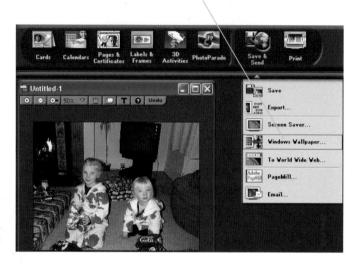

It is also possible to set an image as desktop wallpaper in Windows XP. To

do this, click on the Start button and locate the folder that contains the required image. Then click on it and select Set as Desktop Background.

The image is then automatically set as the desktop wallpaper

Obtaining prints

The printing process is an integral one in digital photography. This chapter looks at some of the options available and how to obtain the best printed images possible.

Covers

The printing process 162
Printer resolution 163
Printer settings 164
Printing speed 165
Inkjet printers 166
Other types of printers 167
Selecting paper 168
Ink issues 170
In-store prints 171
Printing checklist 172

Chapter Ten

The printing process

When you are dealing with halftone printers the term "separations" may

come up from time to time. This refers to the individual color screens that the process creates. These are usually combined to create the overall image but they can also be printed out individually.

If you are working with a commercial printer they will probably ask to see color separations of your images.

Color printing is one area of modern technology that has advanced as much as any in recent years. What was once the domain of professional printers, or a select few who could afford expensive color printers, is now available to anyone with a spare \$100 or more to spend.

It is not essential to know exactly how each type of printer works to produce the end result but it is useful to know a bit about the methods they employ. The two main forms of color printing are:

- Halftone printing
- Continuous tone printing

Halftone printing

Also known as screens, this is the method used by inkjet and laser printers. The image is created by printing a series of dots, or screens, that create the illusion of being a continuous image. However, if you look closely at a halftone image you will be able to see the individual dots of color. As the technology improves it gets harder and harder to identify the dots and when the image is looked at from a normal viewing distance the halftone patterns should not be visible to the naked eye. One problem that can occur with halftone printers is that, if the different screens are not lined up properly, then the final image will suffer from shadowing and the colors will not look entirely accurate.

Halftone printers usually work on the CMYK (Cyan, Magenta, Yellow, Black) color

model while continuous tone printers generally employ the RGB (Red, Green, Blue) model.

Continuous tone printing

This is the method that produces the closest output to true photographic quality. Unlike halftone printing, there is no separation between the color elements of the image and so each part of the image merges seamlessly into the next. If you examine a continuous tone image carefully you will not be able to see the colored dots in the same way as you can with a halftone image.

Continuous tone printing is used for printers such as dyesublimation and it is the route to take for the best images. There are an increasing number of these types of printers now appearing on the market, but they are more limited in the size of prints they can produce.

Printer resolution

As with digital cameras, the resolution of an inkjet printer is one of its main selling features. Resolution for printers of this type is measured in dots per inch (dpi) and, as a rule, the higher the better. Some inkjets currently on the market can print up to 5760 dpi. However, it should be remembered that the printer resolution does not affect the size of the image; this is done by the image resolution setting in the editing software. To recap:

- One measure of image resolution is the number of pixels per linear inch and this can be set within the image editing software. So if an image is 1200 pixels wide and you want a printed image that is 4 inches wide then the image resolution should be set at 300 ppi (pixels per inch)
- Printer resolution is not the same as image resolution but most printers work on a minimum output basis of 300 dpi. If a printer prints at a higher resolution it just recreates each pixel using more colored dots of ink. This increases the quality but does not affect the overall size of the image

Image resolution can be selected within image editing software and this is what determines the final printed size:

Inkjet printers benefit from regular maintenance and the software

allows for various tasks to be performed. Print cartridges should be cleaned (automatically) at regular intervals, particularly if the printer has been left idle for a lengthy period of time.

Whenever you install new cartridges the alignment option should be run.

At different resolution settings within editing software, an image will be printed at different sizes. The higher the print resolution, the smaller the printed image

Printer settings

One area that is often overlooked when outputting color images is the printer settings that can be adjusted via your printer software. All printers come with software that enables them to communicate with a computer and vice versa. In the computer world these are known as drivers, which makes it sound more like a piece of hardware, but it is in fact software.

Adjusting settings

Printer settings can be adjusted when you select Print > Setup from whichever program you are working in.

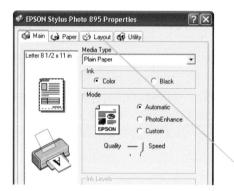

A standard print setup box. This enables the user to select the manner in which the image will be printed and also additional options from the tabs along the top

If you print your images by selecting the print icon that appears on most toolbars

then the printer will use the current print settings. If you want to change anything you will have to do it via your Print dialog boxes or a program such as Print Manager.

Take some time to experiment with different printer settings for your images. They do make a difference and it will increase your confidence in the overall editing process.

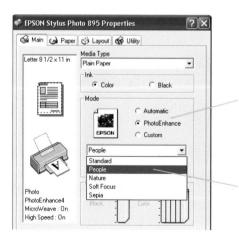

Most inkjet printers have options for enhancing prints for photographic images. In some cases this can also be adjusted for certain types of subject

Printing speed

Headline figures

For once in the computing world, speed is a bit of a red herring as far as color printing is concerned. Most inkjet manufacturers claim their products can print between 2 and 8 pages per minute in color. This can be a major selling point but there are two things to say about this:

- This figure is usually for when the printer is set to its lowest quality setting i.e. draft or economy. This is suitable if you want to get a preview of what your image will look like but it should never be used for the final output
- The headline pages per minute figure is for when you are printing images on standard multi-copy paper. Inkjet printers react differently when they are set to print on different paper types – the better the paper then the slower the print speed

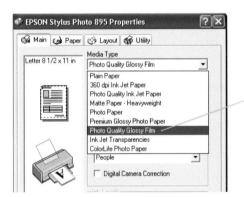

Color inkjets offer a selection of options for paper types. The higher the quality of paper, the longer the image will take to print

One problem to keep an eye out for when color images are being printed is paper

warb. This occurs when the weight of the ink on the paper causes it to warp and buckle. Try and test for this before you buy a printer.

The larger the image, the longer it will take to brint. If you want a full Letter-size

output then this will take a lot longer than for a standard 6×4 photo-size print.

Realistic figures

If you want to get the highest quality of print, on the best paper, the output figure is more likely to be in terms of minutes per page rather than pages per minute. However, for most people who are printing images this does not really matter. Quality certainly beats speed in this case, and so be prepared to wait if you want sharp images. If you also need a printer to produce textual documents then the print speed may become more of an issue. There are some printers on the market that are designed specifically for text and images, but if you are only going to be printing photographs then look for a printer that specializes in this.

Inkjet printers

If you want to use digital images for anything more than displaying on a Web page or a monitor then a good quality color printer is essential. Without it, the images from the highest resolution camera could look grainy or slightly blurry.

The most common type of affordable color printer on the market is generically known as the inkjet printer. This was a name that was first coined by Hewlett Packard to describe a particular printing process and it has since spawned numerous imitators. Two other companies, Canon and Epson, use a similar method but they apply different names; bubblejet for Canon and micro piezo for Epson. Although the technology between the three differs slightly, they are all usually grouped together under the term inkjet.

Always allow color prints to dry thoroughly before you handle them. Depending on the

size of the print and the paper, this could vary from a few seconds to a couple of minutes.

What's it for?

What you intend using your printer for may determine the type that you buy. Some color inkjets are designed specifically to produce high quality color images. They can also print text, but the quality is not as good as a printer designed specifically for that purpose. They also tend to be less economical when printing text. Other printers go for a combination of good color images and text.

The inkjet method

Inkjet printing is essentially a simple process: tiny dots of colored ink are placed onto paper by a collection of miniature nozzles. This is usually done with two cartridges, one containing black and the other containing cyan, magenta and yellow. When they are combined they create the CMYK (K is for black) color model.

Some color printers only have a single cartridge and this usually results in inferior color quality. This is because they cannot produce the same range of colors and their version of black is not true black, more like a murky brown. Always go for printers that have at least two color cartridges.

A handful of more recent inkjet printers have an additional two colors (lighter shades of magenta and cyan) as well as the four in the CMYK model. This increases the color variations available and is effective for subtle color changes such as skin tones.

Some inkjet printers now have individual cartridges for each color used,

instead of having four contained in one cartridge. This can make it more economical as you only have to replace a single cartridge when that color runs out rather than the whole color cartridge when just one of the color is used up.

Other types of printers

Dye-sublimation

Consumer-level dve-sub printers are generally more expensive than their inkiet

equivalents and the price-perpage is higher than an inkjet printer. Also, you do not always have the option of printing in draft auality.

Some dye-sub printers only take one format of memory card, i.e., either SmartMedia

or CompactFlash. If you are considering a printer of this type, make sure it accepts the type of memory card that you use in vour camera.

An increasingly popular type of printer for color images is the dye-sublimation variety. Also known as dye-sub or thermal-dye printers, this is one option that is worth considering if you are only interested in printing high quality color prints. Dye-sub is a process that heats various colored dyes in such a way that they are fused onto the paper. Unlike the halftone effect of inkjet printers, dye-sub printers create a continuous tone image in which the individual dots of color cannot be seen. This gives an excellent end result and is probably the closest you will currently get to traditional photographic standard.

One recent feature of dye-sub printers is the ability of some of them to be able to generate prints directly from a digital camera, as well as printing from a computer. The camera is connected to the printer and a hard copy can then be produced. While this is a useful feature, it removes the editing element so you have to make sure that your pictures are exactly right when they are captured.

One downside of dye-sub printers is that the consumer-level models are sometimes restricted in their output size and they do not handle large volumes very well. Also, dye-sub printers can only be used for printing images. So if, like most of us, you want to print text on occasions, you will need another printer to do this.

Thermal wax and micro dry

Thermal wax printers use a similar heat method to dye-sub but are cheaper for running costs. Micro dry printers also use heat to affix color to the page but in this case it is done through ribbons coated with special inks. This gives a good quality at a reasonable price.

Laser

As a rule, laser printers are faster than inkjet ones and provide a better print quality. However, their main drawback is cost, particularly for color printing. Unless you are willing to spend a lot of money to have your images printed at a higher quality, then color laser printers are best left for the office or professional print bureaus.

Selecting paper

If you want the best print results then go for the best products: a high resolution

printer, photographic quality paper and a photographic ink cartridge.

The reason that glossy photographic paper can broduce results

which are so much better than ordinary multi-copy paper has to do with the coating on the surface of the paper. It is designed to grip the ink more securely so that there is less chance of dots blurring into each other.

Paper types

While one piece of paper may look similar to another, the differences can be considerable when it comes to printing photographic images. Some inkjet printers can give good results on plain Letter-size paper, but if you switch to a type of paper specifically designed for color images then you will notice the difference immediately.

Some of the various paper types available include:

- Standard multi-copy paper. This can be used in inkjet printers, laser printers, fax machines and photocopiers. It is very versatile but gives the poorest quality for photographic images
- Inkjet paper. This is a step up from multi-copy paper and gives good color results on inkjet printers. It is useful for printing items such as company reports that have colored charts and similar images
- Photographic quality paper. This is a generic term for glossy paper that produces results which are as close to photographic quality as you are going to get from an inkjet or laser printer. It is the most expensive type of paper and within this range there is a considerable selection from the main companies such as Epson, Kodak, Hewlett Packard, Agfa, Canon and Ilford
- Matt photographic paper. This is the highest quality photographic paper to be used when quality is paramount

Experiment with different types of paper to see which is the best for the job you are doing

If you are printing images for an OHP presentation, make sure that they are sharp

and clear once they are projected onto a screen. In some cases, color definition and image detail may be lost.

Other printing options

Although the most common paper format is Letter-size this is by no means the only option available. Depending on the type of printer, the following mediums and formats can be used:

- Large format paper. Only certain printers support this format and they are inevitably more expensive than the standard models. However, this is a great way to create poster size prints
- Film transparencies. These are sheets of clear plastic that can have images printed on them for display on an Overhead Projector (OHP). This can be very useful for business presentations and if you have some of your own images it will make a pleasant change from the ubiquitous Clip Art
- Cards. Images can be printed on special size cards. This can also be done onto Letter-size paper and then cut to size, but if you want a professional finish then this is a useful option
- T-shirt transfers. A relatively new product on the market. The image is printed onto the transfer, which is then ironed onto a T-shirt

Branded or generic

Each printer manufacturer has their own brand of photographic paper and they all insist it is the one that works best with their own unique printing system. But in reality there are a lot of other companies that produce photographic quality paper that is of an equally good quality.

One of the main considerations when buying paper may be the cost. The top quality paper is not cheap and you can sometimes save money if you buy paper from companies other than the printer manufacturers. Shop around and test different paper types. It may take a little time until you find a good combination of price and quality.

If possible, buy paper in bulk as this can work out considerably cheaper in the long run. However, always check the quality on your own printer first, before you commit yourself to a large order: if you make a mistake it may be a costly one.

Ink issues

When you change cartridges in your printer, make sure you realign the print cartridges.

This is done via the printer options and is particularly important for photo cartridges if the alignment is even slightly out then this will affect the color of your printed image.

Manufacturers of color photo printers have worked tirelessly in recent years in order to be able to create printers that can produce photo quality prints for the general consumer. With the current top-of-the-line printers this is now possible – it has been achieved by a number of advances in printer technology and also how ink is used in the printing process. In general, color photo printers use either four or six colors of ink when printing digital images. One of these is always black, which means that the other cartridge holds either three or five colored inks:

Three ink color cartridges

A three color ink cartridge containing cyan, magenta and yellow inks. These are mixed with the black cartridge to create a four color printing system that can produce good quality output for digital images.

Five ink color cartridges

A five color ink cartridge contains cyan, light cyan, magenta, light magenta and yellow. The two additional colors allow for a lot more variation of tone and this can produce excellent results, particularly for skin tones and areas of subtle variation. If possible, look for inkjet printers that use a six ink process i.e. five colors and black.

Dealing with fading

It is a fact of digital life that images printed on inkjet printers will fade over a period of time. If an image is kept away from direct sunlight then it can survive for several years before it starts to fade. However, in direct sunlight the fading process may begin a lot quicker. This is another area in which a lot of investment has been made by printer manufacturers and the life-span of printed digital images is increasing continually.

One way to lengthen the life-span of your images is to spray them with water-fast sprays that are available in art supply shops. This gives the image a certain amount of general protection and some sprays also give a degree of protection against sunlight.

Because of this tendency for ink to fade, it is essential that you always keep copies of your favorite images on your computer or backup device. This way you can always print another if the original fades beyond recognition.

In-store prints

Some companies, such as Kodak and Canon, offer online digital printing. The

images are emailed to them and they create the prints and send them back to you in the mail. For more information on this, see Chapter Eleven.

As digital photography gains in popularity the printing world has not been slow to embrace the possibilities that this presents in the way of printing color images for customers. The issue of simplicity, or otherwise, has been a major factor in obtaining prints of digital images but things have improved greatly and it is now possible to get excellent quality prints at reasonable prices from in-store processing. In addition, most film processing and printing companies will save your digital images onto a CD, if required.

If a film processing retailer has a digital printing service they should be able to print images from most digital media, such as camera memory cards, floppy discs and CD-ROMs. If in doubt, check first before you make the trip to the store. Some companies that offer in-store printing services are:

- Canon
- Kodak
- Fujifilm

More information about the Fujifilm in-store printing service, including a Store Locator, can be found at the Fujifilm website at www.fujifilm.com

If you intend making a lot of prints it would be cheaper in the long term to buy

a good quality printer rather than constantly getting images printed in-store.

Professional print bureaus can also be used to get high quality prints. This can be

expensive so only use bureaus for top quality professional work. Before you commit yourself, talk to them about your, and their, requirements.

Printing checklist

Since the printing process is, in some cases, the final one that will be applied to your images before they go on view to the world, it is worth following a checklist for achieving the best possible prints:

- Choose an inkjet printer for a good combination of quality, price and versatility. These are the most commonly available printers and it is possible to find them sold in packages with many computers these days
- Choose a dye-sublimation printer for the very best print quality. These are excellent for printing photographs but they are more restricted than inkjet printers
- Check the price of consumables (ink, paper etc.) when looking at printers. There can be a considerable difference between manufacturers for their own branded products
- Dots per inch (dpi) refers to printed output levels. Printers are usually advertised as having a headline dpi output figure
- Pixels per inch (ppi) refers to the physical size of an image. It is also the measure for determining the print resolution of an image i.e. how many pixels are printed per inch on the paper
- The size of your final image will be determined by your image resolution. This is set by the image editing software. Use 150–300 pixels per inch (ppi) as a standard print resolution with the image editing software
- The resolution of the printer (dpi) improves the quality of the printed image as it uses more colored dots to print each pixel
- Use normal paper and a draft quality setting on your printer for preview prints of your work
- Use photographic quality paper, photo ink cartridges and the highest quality print setting for your final prints
- Leave prints to dry to ensure they do not smudge or smear
- Use a protective coating on your images before you display them. This will increase their longevity

Online images

Displaying, sharing and printing images online is one of the great growth areas of digital imaging. This chapter looks at how to share images over the Web and also get prints from online services. It also looks at the basics of creating Web pages in which to display images and emailing images to family and friends.

Covers

Online sharing 174
Online printing 178
Images on the Web 181
Optimizing images 182
Web authoring options 183
Emailing images 185

Chapter Eleven

Online sharing

A lot of online sharing services also offer printing facilities for images that are

uploaded to the site.

As digital photography has become more popular, one of the issues that the digital image industry has had to confront is how to enable users to distribute their images effectively online. One solution to this has been the emergence of online sharing services on the Web. These are websites that allow users to upload their images into a restricted area on an online sharing service's website and then invite selected people to view them. These services are usually free and they have the advantage of allowing the owner of the images to restrict access to exactly the people who they want to see the images. There are dozens of online sharing services on the Web and some to look at include:

- Club Photo at www.clubphoto.com
- Dot Photo at www.dotphoto.com
- Snap Fish at www.snapfish.com

The method of operation is similar on all online sharing services:

Access the site's home page and click on the Join Now button to register for the service

If you are asked for any type of fee for using an online image sharing service,

then look elsewhere.

Once you have registered you can leave the site and return at a later date to start adding images. Or you can continue and add images immediately. To do this, click on the Add Photos Now button

When you enter vour registration details you will probably be asked if you want

to subscribe to the company's online newsletter, or something similar. This depends on how much extra email you want to be sent, but some of them offer useful advice about services and upcoming offers.

You can create as many albums as you like within your online image sharing site.

Enter a name and description for the album

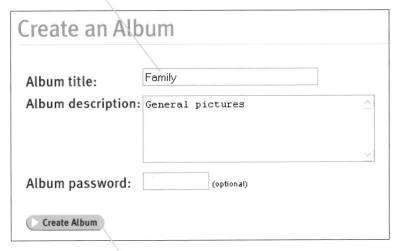

Click on the Create Album button

Make sure that images are in the IPEG format before they are selected for

uploading onto an online sharing site. Otherwise they may not be accepted.

Click on Add Pictures to add images to your newly created

album

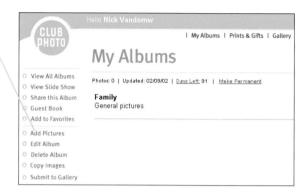

A new album can be created at any time by clicking on the Create Album link from

the page that appears when you log into the site.

Read the instructions for adding images and click on the Add Photo button

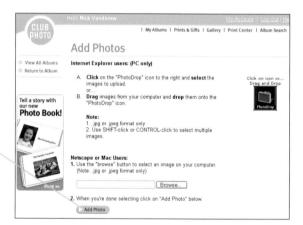

Browse your hard drive and select the images that you want to include. Click on Open

If required, edit images in an image editing program before they are sent for

online printing. Very few images are perfect when they are captured and some careful editing can make all the difference to the final printed image. If possible, do the editing in TIFF format and then save the final image as a JPEG.

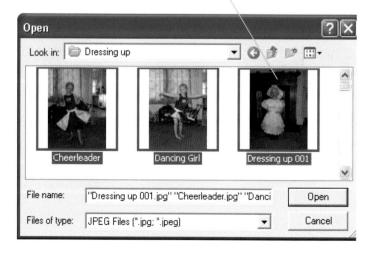

Make sure that any images you upload are of a reasonably small file size. If they

are very large then they will take a long time to upload and they will also take a long time to appear when anyone tries to view them online.

Click on the Upload Photos button to upload the selected images onto your online sharing site

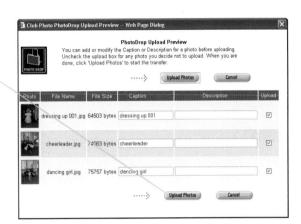

The images can now be viewed in the relevant album

So that other people can see an album and its images, click the Share this Album link and then enter the details of the recipient. Click on Send to invite them to view the album

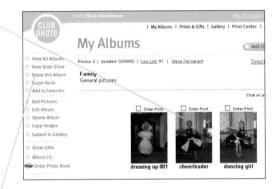

Share with Family & Friends Invite family and friends to view your pictures. Members, take advantage Rewards program and earn FREE shipping! Enter e-mails separated by commas. Use Address Book To: gailvandome@hotmail.com Name F-mail address nick@vandome.freeserve Nick Vandome View my pictures on-line! Subject: Message: Select photo to include in e-mail Photo: None Cancel Send

If you are going to invite beoble to view your images online, it can be worth contacting

them beforehand to let them know what you are going to do. This means that it will not come as a surprise when they receive their viewing invitation.

Online printing

Although the price of prints from an online brinting service can seem quite high

compared to traditional film prints, it can be cost effective because you only need to print the images that you want.

As well as online image sharing, online printing is another growth area for digital photography. Companies that have previously produced prints from traditional film have now developed online sites that can be used to download digital images and then have them printed and sent to you. There are a lot of websites that offer this service including:

- Kodak at www.kodak.com
- Fotango at www.fotango.com

The following is the process for obtaining online prints from Ofoto on the Kodak site:

The quality of prints can vary between sites and also different orders from the

same site. Always check your prints carefully and if you are not satisfied with them, send them back. As long as there was nothing wrong with the original image, they should be reprinted at no additional charge.

Go to the Kodak site and click on the Ofoto link

Enter your registration details (it is free to register) and choose the Click to Join button

Click the Add Photos button to select the images that you want printed

Click the Create New Album button and enter details for an album in which to put your images. Click Next

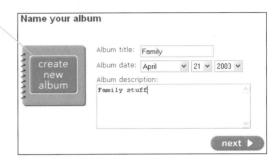

Click here to browse for the images you Make sure that want to use vou select all of the images that

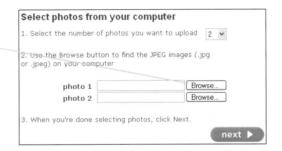

at the first time of asking. In some programs you cannot return to the selection dialog box once you have clicked on the Add button.

you want to print

Select an image from your hard drive and click Open. When all of the images have been selected. click Next in the Select Photos window

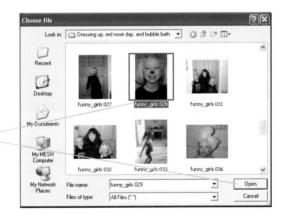

Click here to order prints of the images in your album

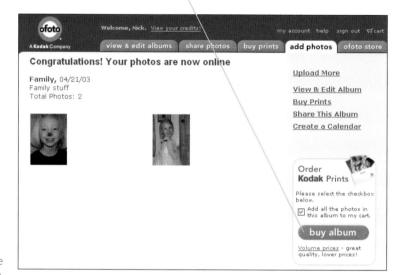

You should aim for the highest resolution possible when using an online

printing service. However, this will mean that the file sizes are quite large and so it could take a few minutes to upload each selected image.

Select the options you want for printing and click Next to move to the checkout where your details for purchasing will be taken

Images on the Web

Three books that provide a general look at the Internet and Web page

creation are:

- "Internet in easy steps"
- · "Web Page Design in easy steps"
- "Web Graphics in easy steps"

Web pages are becoming increasingly popular with a wide range of people, from individuals to big business. In almost all cases, people want to include images on their Web pages. Particular file formats are used for inclusion on Web pages (these are looked at in greater detail in Chapter Seven, pages 120-122):

- GIF (Graphical Interchange Format); GIFs display a maximum of 256 colors and are best used for graphical images such as logos. However, they can also be used for photographic images
- JPEG (Joint Photographic Expert Group) is the main file format for photographic images on the Web. JPEGs can display 16 million colors and a lot of digital cameras automatically save images as JPEGs
- PNG (Portable Network Group) file format is a relatively new one. It uses 16 million colors and lossless compression, as opposed to IPEG which uses lossy compression

Using images carefully

When using images on Web pages there are some general points that should be kept in mind:

- Use images for a specific purpose, not just because you can
- Keep the file size as small as possible
- Limit the number of images on a single page. If you use a lot of images then their impact will be diluted
- Use thumbnail images where possible. These are small versions of larger images. Users can then be given the option of viewing the larger versions by clicking on the thumbnails. However, if they do not want to see the larger versions, they do not have to
- Be consistent in the use of images. For instance if you are using an image as a logo, make sure it appears in the same place on all pages

Applets (small self-contained programs) can be used to create special effects for

Web images. One program to try is Anfy at:

www.anfyteam.com

Optimizing images

Modem is an abbreviation for MOdulator/ DEModulator. Modems are

either external or internal and they convert analogue signals into digital ones.

If possible, try to keep images for the Web well under 100Kb in size.

When you are considering the issue of images and file size the following points should be near the top of your checklist:

- Do you really need to include the image? Does it add anything to the website or are you including it because you like the image yourself?
- Can the image be made smaller? For instance, could it be cropped so that any superfluous parts of the image are removed?
- Can the image be included as a thumbnail? This enables the user to see a small version of the image, which they can click on and enlarge if they are interested

Another consideration for file size and downloading time is that not all users will have the most modern modems with which to access your pages. The current fastest modems operate at 56Kb per second, while some older models only transfer data at 33Kb or 28Kb/sec. If you feel this is going to be an issue for your pages then be very frugal with your images. If you are not too concerned then design your pages with the fastest modems in mind and hope that those who need to will upgrade at some point.

Professional level image editing programs such as Adobe Photoshop and Macromedia Fireworks have options specifically designed to optimize images for use on Web pages. If you are going to be using a lot of Web images then these are worth looking at.

If you are using images on a personal Web page then downloading time may not be such an issue. But if you are creating a corporate website or an intranet then there should be a clear policy regulating the use of images.

A lot of digital cameras on the market today are capable of capturing images

at sizes that are far too big for publication on a Web page. If you are going to be using a digital camera just for Web images then an entry-level one would be more than adequate for your needs.

Web authoring options

Web pages can be created with a Web authoring program, or an online Web publishing service can be used.

HTML authoring pages

If you want to produce your own Web pages then you will have to either take a crash course in Hypertext Markup Language (HTML) or use a dedicated Web authoring program such as Macromedia's Dreamweaver or Adobe's GoLive.

An excellent starting point for learning about HTML is "HTML in easy steps" in

the Computer Step range.

Web authoring programs are known as WYSIWYG (What You See Is What

You Get) programs because what you enter in the Web authoring environment is what is shown when the page is displayed in a browser.

If you want to create a Web page there are four ways to go about it:

- With raw HTML in a text editor such as Notepad. For this you will need to have good knowledge of HTML coding
- With a HTML editor such as CoffeeCup (www.coffeecup.com). Again, HTML knowledge is required, but programs such as this make it a lot easier to create HTML files
- With a Web authoring program such as Macromedia Dreamweaver, Microsoft FrontPage, Adobe GoLive
- With the "Convert to HTML" function that programs such as Microsoft Word and Microsoft Publisher have

Of these four options the best two are probably a HTML editor or a dedicated Web authoring program. Both of these offer help with adding the HTML content and a lot of work can be done without any knowledge of HTML at all.

HTML editors. such as CoffeeCup, have a graphical interface to help create HTML coding

Since online Web publishing services use a variation on their own name in the Web address

of your page, it is inevitably a bit cumbersome. This is okay for personal pages, but if you want something a bit more professional then you should consider registering your own domain name.

A domain name is a unique name that you choose for your website e.g.

www.ineasysteps.com. A fee has to be paid to register a domain name and there are hundreds of companies on the Web that offer this service. Once you have a domain name, you will then require a company to host your site. Most companies that register domain names also run a hosting service.

Online Web publishing

In recognition of people's desire to create their own presence on the Web, several companies now provide an online Web publishing service. This allows users to create their own Web pages and then display them by posting them onto the company's site. Page creation can be done through the use of templates and wizards, or you can create your own pages and then put them onto the site. All individual sites have their own unique URL (Uniform Resource Locator), or Web address, although it will be prefixed with a version of the hosting company's name. Most online Web publishing services are free and they offer a quick way to create a presence on the Web. Some sites that offer online Web publishing services include:

- Yahoo GeoCities at http://geocities.yahoo.com/home
- Apple HomePage at www.apple.com
- AOL at www.aol.com

All online Web publishing sites allow users to insert their own images into pages.

Sites such as Yahoo GeoCities enable quick Web page creation for personal pages and the inclusion of your own images

Emailing images

Email is one of the most accessible and effective elements of the Internet. Communication is fast and cheap and it is an excellent way to send images around the globe in seconds.

Some of the uses for email images are:

- Letting family and friends around the world know about a new arrival – and letting them see him or her
- Holiday snaps before you have even got home yourself
- Business use, such as emailing an image of a piece of broken equipment to see if an online solution can be found
- Business documents that have been scanned can be emailed as digital images. (Be careful with these types of images if there is a lot of text – the images will have to be big enough to be able to see the text, but not too large, for downloading purposes)
- In crime prevention, emailing images of known criminals who may be moving around the country

Before you start emailing your images you should consider the format in which you are going to send them and the method the recipient is going to use to view them.

As with Web images, it is best to keep images for emailing as small as possible as this speeds up the downloading time. However, if the recipient intends to print out the images then you may want to increase the resolution so that they get as good a hard copy as possible. Weigh up these options of speed against quality, depending on the intended use.

Even if the recipient does not have an image editing program, they will still be able to view the image via their Web browser, as long as the file is in GIF or JPEG format. If they have an email connection then they will almost certainly also have a browser. To open an image all they have to do is double-click on the email attachment and the browser will automatically open it. It may be advisable to include instructions to this effect in case the recipient is unsure about what to do with the attachment.

If you have to email very large images to someone. contact them first

so that they know what to expect and will not be surprised when their email program takes much longer to download messages from the server.

If you are unsure whether the recipient of your email will be able to open a

particular file type, save it first in your image editing software as a GIF or a IPEG.

The process of emailing an image is as follows:

Several images can be attached to an email. However, this creates a larger

message to transmit and increases the chances of some of the data being lost on its journey through Cyberspace.

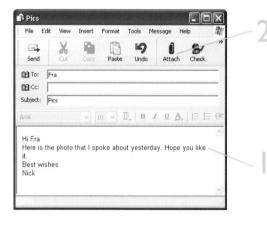

Select the Attach icon, which looks like a paperclip (in Outlook and Outlook Express)

Open your email program and compose your email in the usual way

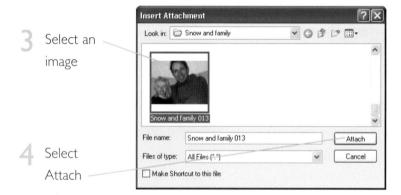

If the image that is attached to the email is not a GIF or a JPEG then the recipient will

have to open it with an image editing program or a utility program such as Paint.

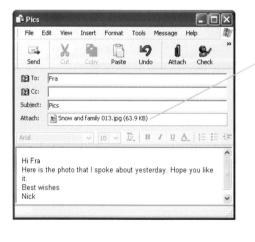

The file will now appear as an attachment. This can be opened and viewed by the recipient

Index

A

B

Accessories 41–42
Buying 42
ADC See Analog to Digital Converter
Adobe
GoLive 183
InDesign 15
PageMaker 15
PhotoDeluxe 113, 119
Photoshop 36, 115, 119, 123, 126, 133-134
Photoshop Elements 36, 59, 69, 113, 115–116,
124, 156
Using layers 146
Advanced Photo System cameras 150
Analog to Digital Converter (ADC) 10
AOL 184
Apertures 57
Apple 102
HomePage 110, 184
iPhoto 103
Assigning keywords 107
Creating a book 110
Cropping images 109
Editing images 109
Importing images 105
Obtaining 103
Organizing images 106–108
Photo Library 104
Removing red-eye 109
Searching for keywords 108
Sharing images 110
.Mac 110
Website 110
Applets 181
Archiving images 40
Auto Levels 130

Backgrounds 80
Backlighting 69
Batteries 42, 52–53
Charging 56
Black and white images 130
Blurring 140
BMP. See File formats
Brightness 131
Browsers 13, 121
Buildings
Exteriors 74
Business uses 79

123 -

```
Cable transfer 35
Cables 27
Calendars
  Creating 155
Camera bags 41
Camera software 58–59
Canon 166, 168, 171
Card readers 34-35
Cards
Creating 155
CD writers 40
Charge Coupled Device 10, 60. See also Image sensors
Children
  Activities 78
  Portraits 77
Cleaning equipment 42
Clip Art 117, 169
Cloning 127, 135-136, 138, 142-143
Cloning tool 143
Close-up. See Focus
CMOS image sensors 10
CMYK color model 23, 162, 166
CNET 37
CoffeeCup 183
```

Collages 147 Creating 148-149 Color Adding to an image 153 Color balance 133 Color photocopiers 15 Colors Depth 24 In digital images 23 CompactFlash 33-34, 62, 167 Composition Using backgrounds 80 Using grids 81 Using natural elements 82 Compression. See also Images: Compressing Camera 50 Lossless 120 Lossy 120 LZW 122 Computer memory 31 Computers Apple Macs 30 Choosing 30-32 PCs 30 Consumables 33 Contrast 132 Cropping 137

Depth of field 63, 70-71 Desktop Publishing (DTP) 15 Digital cameras 8 Buying checklist 62 Consumer 44 Functions 46-47 Megapixel 18 Price 26, 44-45 Professional 45 Requirements 27 Researching 28-29 Specification 32 Workings 48-49 Digital images Emailing 13 Multimedia 9 Viewed on television 9 Digital photography Defining 8, 11 Disadvantages 12 First steps 10-11 Using 9 Distortion 156-157 Dots Per Inch 20, 163, 172

Emailing images 185-186 EPS. See File formats Exposure 48, 63, 66-69, 71

f-stops 67 Equivalent 66 Feathering 135, 141 File formats BMP 122 EPS 122 FlashPix 122 GIF 24, 120 IPEG 120-121 Photo CD 122 PNG 22, 121 Proprietary 123 RAW 120 TIFF 122 File size 50 Film photography 10 Film speed 49 Film transparencies 169 Filters 138, 156–157 Flash 64-68, 74 Details 57 Fill-in 69 Using 55 Flash memory 34 FlashPix. See File formats Floppy discs 34, 39 Focus Auto 65 Close-up 65 Fixed 65 Infinity 65 Foveon X3 11 Freehand tool 135 Fujifilm Digital Imaging 171

Getting prints
In-store 171
GIF. See File formats
Grids 81. See also Rule of thirds

Hotspots 68 HTML 183 Converting files to 183 Editors 183 Web authoring 183 Hue 132

> Coloring 23 Compressing 22 Dimensions 20

Image editing software 10, 23, 27, 59, 172, 176 Brightness 131 Color adjustment 130 Color controls 131 Contrast 132 Entry-level programs 37, 112-113 Fun packages 38 Professional programs 36, 114-115 Saturation 132 Selecting an area 135–136 Special effects 125 Touch-up techniques 124 Image information 57 Image sensors 10-11, 17, 49-50, 55 **Images** Adding colors to 153 Adding text to 152 Adding to T-shirts 154 Archiving 40 Black and white 130

Distorting 156-157 Downloading Via Mac OS X 102 Via Windows XP 84-87 Draft printing 129 Duplicating 136 Editing 128 Emailing 185-186 Magnifying 119 Obtaining 60-61 On the Web 20, 181 Opening 116-117 Optimizing 182 Outputting 20-21 Printing 99-100 Resizing 19 Saving 123 Saving a copy 129 Using In iPhoto (Mac OS X) 105-110 In Windows XP 91-96 Views 92-95, 118-119 Indexing programs 11 Ink Fading 170 Five ink cartridge 170 Three ink cartridge 170 Internet 9 Displaying images 181 Getting images from 61 Intranets 13 iPhoto. See Apple: iPhoto ISO ratings 49

Jaggies 144
IPEG. See File formats

Kodak 168, 171 Photo CD 122

Labels Creating 155 Landmarks 72 Landscapes 73 Layers 146 Adding 147 Adding text 146 Palette 146 LCD panels 52-53, 56-57, 64, 75, 78 As a viewfinder 53 Lenses 42 Fixed focus 54 Zoom 54 Levels Adjusting colors with 134 Adjusting problems 68 Exposure settings 67 Fill-in flash 69 Low light 67

Mac OS X 58, 62, 101-110 Magazines Camera 28 Computer 28 Memory cards 11, 34, 41, 72 Memory stick 34 Microsoft FrontPage 183 Picture It 113 PowerPoint 26 Publisher 15, 183 Word 183 Modems 182 Monitors 32 Multimedia Card 34

Natural elements Composing with 82 Negative space 82 Newsgroups 29 Newsletters 15 Noise 127, 144

On-board memory 51 Online images 181 Online photo sharing 16, 174-177 Adding images 176 Registering 174 Sharing images 177 Viewing images 177 Online printing 171, 178–180 Print options 180 Resolution 180 Uploading images 179 Online publishing 184 Opening images 116–117 OS X. See Mac OS X Overexposed images. See Image editing software: Brightness

Paint Shop Pro 115, 119, 126, 146 Panoramas 150-151 Paper Cards 169 Inkjet 168 Multi-copy 21, 168 Photographic 21, 155, 168 T-shirt transfers 169 Paper warp 165 Parallax 64 PC Card 34, 51

People Groups 75 Portraits 76 Photo CD 9, 61. See also File formats Photographs Repairing 158-159 PhotoDeluxe. See Adobe: PhotoDeluxe Photo Express. See Ulead: Photo Express PhotoImpact. See Ulead: PhotoImpact Photoshop. See Adobe: Photoshop Photoshop Elements. See Adobe: Photoshop Elements PhotoSuite. See Roxio: PhotoSuite Picture and Fax Viewer 93, 96 Picture It. See Microsoft: Picture It Pixelation 17 Pixels 18, 24, 44-45, 50, 54, 60-62, 118, 132, 144 Duplicating in cloning 142 Understanding 17 Pixels per inch 19 Plug and Play facility 88 Preview function 131 Printer settings 164 Printers 33 Bubblejet 166 Choosing 33 Dye-sublimation 33, 167 Inkjet 20, 33, 163, 165-166 Laser 33, 167 Micro dry 33, 167 Micro piezo 166 Print cartridges 166 Thermal wax 167 Printing Checklist 172 Continuous tone 162 Halftone 162 In-store outlets 171 Printing speed Headline figures 165 Pages per minute 165 Realistic figures 165 Projects 126

R

RAM 31–32
RAW. See File formats
Rectangle tool 135
Red-eye reduction 55, 138
Removable memory 51
Adapters v. card readers 34
Removing blemishes. See Cloning
Removing objects. See Cloning
Resampling 19
Resizing 19

Resolution 7, 13, 18, 20–22, 43, 50–52, 60–62, 161, 163, 166, 168, 172

Camera 19

Image 19–20

Outputting 20

Types 18–19

RGB color model 23, 162

Roxio

PhotoSuite 113

Rule of thirds 73, 81–82

Saturation 132
Saving images 123
Scanners 9, 60–61, 158
SD Card 34
Sharpening 139, 144
Shutter speed 48, 57
Single Lens Reflex 42
Slideshows
Creating 98
SmartMedia 33–34, 62, 167
Softening 140
Special effects 125, 156–157
Stitching. See Panoramas
Storage devices 39–40

T-shirt transfers 169
T-shirts
Creating images on 154
Text
Adding to an image 152
TIFF. See File formats
Trace. See Freehand tool
Tripods 41, 150–151
TV playback 57
TWAIN compliant 60

Ulead 123 Photo Express 59, 113 PhotoImpact 115, 146 Underexposed images. See Image editing software: Brightness USB 27, 30, 35, 39

Video grabber 9 Viewing images 118–119

Wallpaper Creating 160 Web authoring 183-184 Web pages Downloading times 182 File size 182 Web publishing 184 Corporate websites 13 Personal websites 13 Rules 14 Webcams 44 Websites For digital imaging 29 What You See Is What You Get. See WYSIWYG White balance 68 Windows XP 58, 62, 83 Adding digital devices 88-90 Image details 97 Images Adding 84-87 Printing 99-100 Organizing files 97 Picture and Fax Viewer 93, 96 Printing 99

Viewing images 91–96 Views 92 Details 95 Filmstrip 93 Icons 95 List 95 Thumbnails 94 Tiles 94 WYSIWYG 183

xD Card 34 XP. See Windows XP

Yahoo GeoCities 184

Zip drives 39 Zoom lenses Digital zoom 54 Optical zoom 54

Slideshows 98